V E R O N E S E

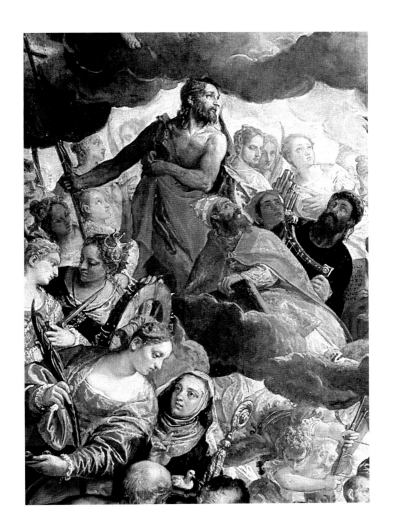

CHAUCER PRESS

20 BLOOMSBURY STREET, LONDON WC1B 3JH

© CHAUCER EDITIONS, 2005

ISBN 1 904449 36 0

A COPY OF THE CIP DATA IS AVAILABLE FROM THE

BRITISH LIBRARY UPON REQUEST

DESIGNED BY POINTING DESIGN CONSULTANCY

FIRST PUBLISHED IN 1980. THIS EDITION WAS EDITED BY CHRISTOPHER WRIGHT

AND REVISED AND UPDATED BY RICHARD COCKE

TYPSET BY ROWLAND TYPSETTING

PRINTED IN CHINA BY SUN FUNG OFFSET BINDING CO. LTD.

PICTURE ACKNOWLEDGMENTS: AKG, BRIDGEMAN, CORBIS

HALF TITLE: DETAIL OF 'CORONATION OF THE VIRGIN"

FOR SARAH

VERONESE

RICHARD COCKE

CHAUCER PRESS
LONDON

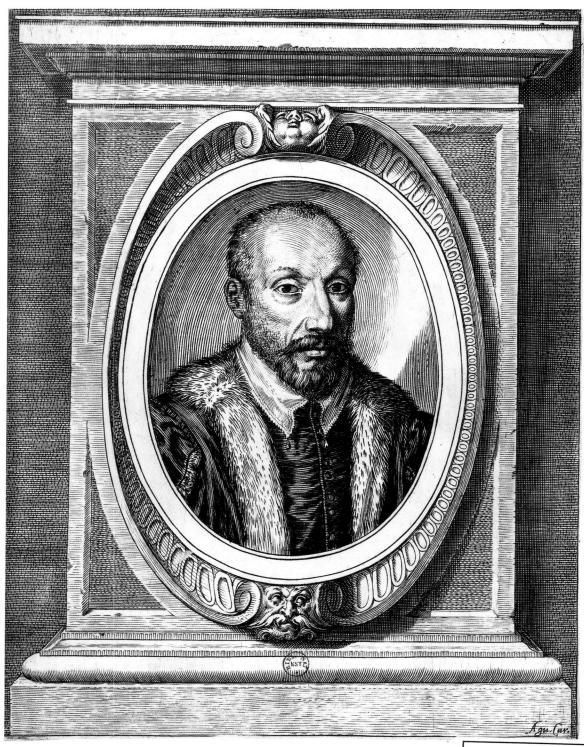

Frontispiece *Paolo Veronese*
by Agostino Carracci (1557-1602), Engraving,
PARIS, Bibliothèque Nationale.

VERONESE

VERONESE'S paintings enjoyed an almost unchallenged reputation at least until the end of the nineteenth century. When in 1858 John Ruskin delivered his inaugural lecture as Slade Professor in the University of Cambridge he included a notable passage on *The Queen of Sheba before Solomon* in Turin (Plate 66): 'Well, one of the most notable characters in this picture is the splendour of its silken dresses; and in particular there was a piece of white brocade, with designs upon it in gold, which was one of my chief objects in stopping in Turin to copy. You may perhaps be surprised at this; but I must just note in passing that I share this weakness of enjoying dress patterns with all good students and all good painters . . . all the accessories are full of grace and imagination; and the finish of the whole so perfect that one day I was upwards of two hours vainly trying to render, with perfect accuracy, the curves of two leaves of the brocaded silk.'

We have no contemporary accounts to match Ruskin's, but the inaugural performance of Sophocles' *Oedipus the Tyrant* at Palladio's newly completed reconstruction of a Roman theatre, the Teatro Olimpico, Vicenza on 3 March 1585 is testimony to Veronese's reputation. The production was supervised by committees, including one for the design and materials of the costumes. These were worked up by Alessandro Maganza from drawings by Veronese (Fig.1). Maganza's choice of collaborator is understandable in view of the *Queen of Sheba before Solomon*, and contemporary reported that Oedipus had a guard of twenty-four archers, dressed like those of the Sultan of Turkey, Jocasta was accompanied by ladies in waiting, Creon had a suite to match his rank and the chorus numbered fifteen.

Although Ruskin rightly evoked the staggering skill that we can find throughout Veronese's work, and this enthusiasm influenced the Pre-Raphaelites, he was unaware of the way in which Veronese used his undoubted virtuosity to tell a story. The rich brocades of Sheba and her suite

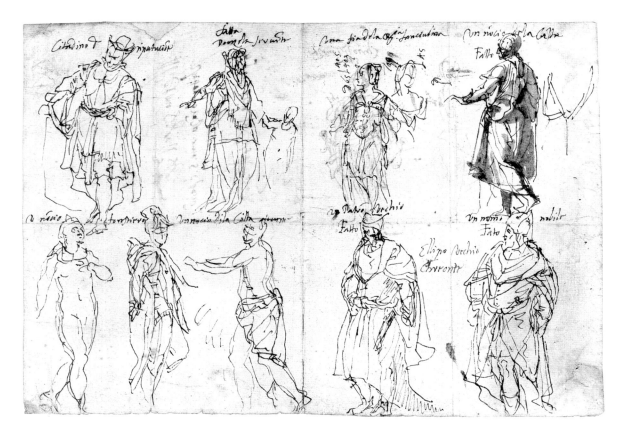

Fig. 1 *Costumne Studies for Oedipus the Tyrant,* 1584.
Paolo Veronese, Pen, ink and wash,
BOSTON, E.W. Seibel.

are part of the great sweep which leads up to the youthful Solomon enthroned to the left of the canvas; the composition is very freely based upon an engraving by Marcantonio Raimondi after Baldassare Peruzzi but the youthful Solomon has been substituted for the middle-aged figure in the print. This is an idealized reference to Charles Emanuel who had commissioned the canvas soon after his accession as Duke of Savoy in 1580, and the rich costumes embody the flattery of II Chronicles 9: 'happy are these thy servants which stand continually before thee'.

Veronese had been born Paolo Spezapreda, which means 'stonecutter', in Verona in 1528; his early training is unclear, for his style, owes little to Antonio Badile or Giovanni Francesco

Caroto either of whom may have been his master. He was one of a generation of young painters, including Battista Zelotti and Paolo Farinati among others, who were to follow the example of the more successful artists of the city and make their careers in Venice, where he is first documented in 1555, having changed the family name to Caliari. Veronese must have moved to Venice because of the commissions offered for the redecoration of the rooms of the Consiglio dei Dieci in the Ducal Palace (Plates 7 and 8) a project which brought him into contact with some of the most important members of the Venetian patriciate. Others from outside Venice participated in the redecoration, but, Veronese alone established himself in Venice and the Veneto.

By the end of his career he was so successful that, as with Giovanni Bellini before him, he signed paintings which had been produced entirely by the workshop, which for a time at least continued after his death in 1588. Although his career can essentially be measured through his work for the Venetian patriciate, he was in contact with a wider clientele. Early in the 1580s Philip II of Spain instructed his agent in Venice to see whether Veronese might come to work on the decoration of El Escorial, because he thought Veronese to be a better painter than Federico Zuccaro, with whom he was negotiating. He was right (as Zuccaro's dull work testifies) but unsuccessful with the aging Veronese.

One key factor in shaping Veronese's career was his command of the north Italian tradition of narrative variety, embodied in the work of Antonio Pisanello (1395-1455). The central element in Veronese's commissions, be it an altarpiece, private devotional painting or the frescos at Villa Maser, is expressed with pictorial clarity and witty incidental details, often animals, which make the subject accessible. During the years 1548 to 1555 he was influenced by the new Venetian interest in artistic theory, shown in the publication of Paolo Pino's *Dialogue on Painting* in 1548, Doni's *Disegno* in 1549 and in Dolce's *Aretino, or Dialogue on Painting* of 1557. That some of these theoretical considerations were of immediate importance for Veronese is suggested by the earliest criticism of his work, that written by Francesco Sansovino, the scholar son of the great architect, in the first edition of his guide-book to Venice of 1556. He

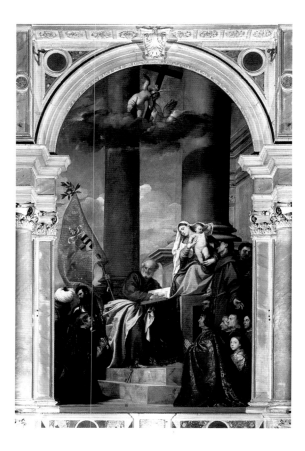

Fig. 2 *Pesaro Altar*
TITIAN
VENICE, Frari.

Fig. 3 *Holy Family with St John the Baptist (Madonna della Perla)*
RAPHAEL
MADRID, Museo del Prado.

described Veronese's contribution to the redecoration of the rooms of the Consiglio dei Dieci in the Ducal Palace (Plates 7 and 8) as: 'opera veramente di disegno et gentile'. *Gentile* has a wide range of reference meaning both noble (as distinct from plebeian) and well and skilfully made. *Disegno* (the term combining the process of design with the practice of making prepartory drawings) is the crucial term which the theorists connected with central Italian artists and whose absence in Titian's work was lamented by Vasari in his *Lives of the Artists* in 1550 and again in the 1560s.

Sansovino's use of the concept *disegno* for *Jove Expelling Crimes and Vices* (Plate 8) recalls a now famous passage in Pino: 'if Titian and Michelangelo were of one body or if to the *disegno* of Michelangelo were to be joined the colouring of Titian he could be called the god of painting.' Neither Pino nor Doni give a clear account of *disegno*, failing to emphasize either the range of drawings used in the preparation of a composition or the importance of drawing from the life.

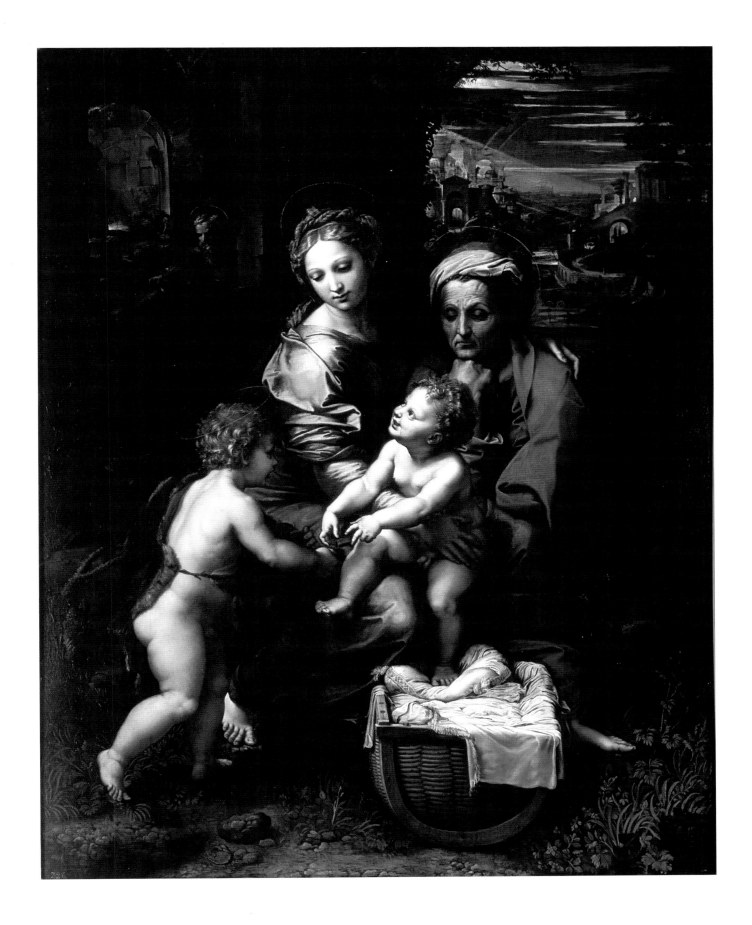

Fig. 4 *View of the ceiling of the sacristy, S. Sebastiano, Venice*

It is therefore not surprising that, although both Veronese and Tintoretto were inspired by the programme that Pino proclaimed, their working procedure and their style should owe more to Venice than to central Italy.

Veronese appears to have taken Pino's programme literally, so that there are at least two drawings for his earliest painting the Madrid *Christ Preaching in the Temple* (Plate 1) of 1548, a rapid pen and ink sketch, which owes much to Parmigianino, and a chalk study for the scribe with a book at Christ's feet owing much to Titian's chalk studies. Jerusalem, otherwise inaccessible to a youthful artist in Verona, was evoked through the scribes' exotic head-gear and the curved Corinthian colonnade. This suggests pride in Verona's Roman remains, further echoed in the choice of compositional model, by the Veronese painter Bonifazio de' Pitati (1487-1553), who had made his career in Venice. The debts are means to a narrative end. Christ, singled out by double columns, is surrounded by scribes, whose reactions range from the doubters, scrabbling in their books, to the intense gaze of believers, including the donor (identified by the Cross of Jerusalem to indicate that he had made the pilgrimage to Jerusalem).

This aspect of the *Christ Preaching*, which continues in the paintings of the 1550s, is matched by a treatment of colour that is Venetian, both in the breadth of handling, which recalls that of mature Titian, and in the way in which it balances richness with a sense of narrative. In spite of

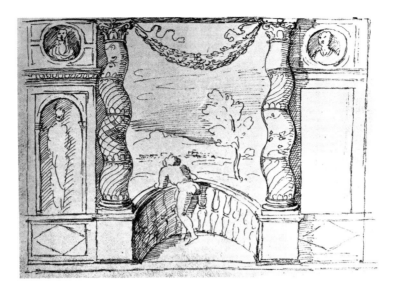

Fig. 5 *Sixteenth century copy after a lost decoration in Mantua by Giulio Romano* Anon.
BERLIN.

the shadow created by his upraised arm, the pink of Christ's robe is the lightest tone in the canvas, and hence the focus for the colour just as all the gestures and glances concentrate upon this figure.

Everything about the *Christ Preaching in the Temple* underlines why it is so difficult to accept the traditional view that Veronese was trained by either Badile or Caroto whose efforts to assimilate sixteenth century sources were hampered by their sharp, harsh treatment of draperies, a continued legacy from the work of Andrea Mantegna, which had had profound repercussions for painting in the city from about 1460 onwards. Here and in the next decade Veronese was to give the tradition springing from Mantegna renewed life, for the palette in the *Christ Preaching in the Temple* emphasizes yellows and greens in addition to pink in a way that is not found in Titian, but which looks back to the range of colours that Mantegna employed in the series of the *Triumph of Caesar*, which formed an outstanding part of the Gonzaga collection in Mantua.

The range of sources for the *Christ Preaching in the Temple* continues in the paintings of the 1550s; the expressive torso of the tempter attacking the prostrate saint in the *Temptation of St Anthony* (Plate 4) of 1553 was suggested by Caraglio's engraving after Rosso Fiorentino's

Hercules and Cacus and the elegant St. Catherine of the *Holy Family Enthroned with John the Baptist, SS Anthony Abbot and Catherine* (Plate 3) derives from an etching by Parmigianino. The position of the Holy Family on the right of the canvas, the twin columns behind them and the high pedestal on which they are placed with the saints beneath reveal Veronese's study of Titian's Pesaro altarpiece (Fig. 2), here combined with incidental wit in St John's unequal struggle with his lamb and the wicked glint of St Anthony's boar, sharpening its teeth on the fallen masonry, the symbol of paganism overcome by Christianity. The vigorous twisting Fame in the *Time and Fame* (Plate 2) of the same year, 1551, reveals his interest in Giulio Romano, an interest that was to mature in the great decorative achievements at S. Sebastiano and Maser, (Plates 9–12, 15–21). The complex foreshortened St. Paul in the *Conversion of St. Paul* (Plate 5) derives from the Laocöon but the changes in the pose and costume suggest that, like Tintoretto, the figure was studied from a model. Although undated the overcrowded action of the *Conversion of St Paul* does not fit with later pictures; the energetic leaping horses that distract attention from the fallen saint anticipate those in S. Sebastiano (Plate 11) and derive (although with much greater energy and movement) from a painted facade on the Corso in Verona.

The fleeing horse in the background accompanied by a servant has been studied from Raphael's cartoon of the *Conversion of St Paul* which was then in the Grimani collection in Venice. The interest in Raphael resulted in a now lost copy after the *Madonna della Perla*, (Fig. 3) which is now in Madrid but which in the middle of the sixteenth century was in the Canossa collection in Verona; this study influenced the elegant swirls of the Virgin's drapery in the *Coronation of the Virgin* (Plate 9) with which Veronese began the decoration of S. Sebastiano late in 1555. The light, rather unusually bright colour is very different from the heavy shadows of the Raphael, and the poses of the Virgin and of Christ, look back to earlier Venetian versions of this subject. The decorative panels around the central rectangle are filled with cartouches and rich swags, which derive from engravings after the school of Fontainebleau, and which anticipate the later development of Venetian ceiling frames.

Veronese achieves a new complexity of pose in the foreshortened St. John the Evangelist who looks up to witness the Coronation in heaven above his head; the pose suggests the example of the Sistine ceiling (notably the Jonah) which he may have seen before painting the ceiling of the sacristy at S. Sebastiano (Fig. 4). According to an old tradition he visited Rome together with Girolamo Grimani; Grimani was *capo* of the Consiglio dei Dieci in 1555, one of the three years that he visited Rome, and it is reasonable to assume that he took with him on this trip the young Veronese, who was then involved in the decoration of the suite of rooms in the Ducal Palace that the Consiglio dei Dieci occupied (Plates 7 and 8). The paintings of the following years (Plates 6 and 7) reveal Veronese's new awareness of Roman painting; the monumental Age in the *Youth and Age* (Plate 7), for instance, fuses the pose of the Daniel on the Sistine ceiling with the head of Ezechiel and the discrepancy between the steep angle at which the seat is viewed (notable in the step) and the much flatter handling accorded the figure recalls Michelangelo's *ignudi*.

We have lost earlier illusionistic ceilings from the Ducal Palace, destroyed by fire, but the freedom with which the figures move in the great *Jove Expelling Crimes and Vices* (Plate 8) suggests the majestic freedom with which Michelangelo invested God the Father in the history scenes in the second half of the Sistine ceiling (from the *Creation of Adam* to the altar) rather than any Venetian precedent. The firmness with which the figures are modelled recalls Sansovino's choice of epithet for these canvases: *disegno*; this, however, is only half the story for the *disegno* is combined with a rich play of light and shade and with the contrast between the white clouds and the brilliant blue sky.

The rooms in the Ducal palace are small when compared with the nave of S. Sebastiano (Plates 10–12), for which Veronese produced one of the most splendid decorative ensembles of the sixteenth century, in 1556 and 1557. Venetian ceiling design had been given a new impulse in the previous decade by Titian's great ceiling in Santo Spirito which has now been

removed to the sacristy of S. Maria. della Salute. Titian conveyed the drama through the enormous figures, sombrely lit in front of dark skies which open in the *Sacrifice of Abraham* to underline the presence of the Holy Spirit, an allusion to the dedication of the church.

As with other Venetian ceilings the complex heavy gilded frame was already in position establishing the contrast between the central square (Plate 12) and the two flanking ovals (Plates 10a and 11) and calling for the smaller canvases which flank the main narrative scenes. In these smaller scenes Veronese has brilliantly reinterpreted the illusionistic oculus of Mantegna's Camera degli Sposi in the Ducal Palace at Mantua with sharply foreshortened balustrades on top of which vigorous small angels support garlands. The grisaille figures in the corners besides the oval canvases look back to the spandrel figures on Roman triumphal arches, but those by Veronese are handled with a vigour and liveliness that had eluded his collaborators at the Ducal Palace.

As with Titian, Veronese has taken the spectator into account so that the ideal viewpoint for the central *Coronation of Esther* (Plate 12, is as one enters the church from under the monks' choir and that for the *Triumph of Mordechai* (Plate 11), which is towards the altar, is from under the *Coronation*. The spectator could not look up directly at the first canvas in the series, the *Esther Brought Before Ahasuerus* (Plate 10a), because of the monks' choir and this canvas is therefore turned on its axis so that it is viewed from the centre of the church (under the *Coronation*) with the spectator's back turned to the altar.

The colours, especially after the restraint of Titian, are striking, with the emphasis upon greens, reds and yellows, which are strongly reminiscent of Mantegna's *Triumph of Caesar* series. The colour is not, though, an end in itself (although this is the impression that you will get if you are unfortunate enough to see the ceiling by the artificial lights that are installed and which upset the balance); in the *Coronation* (Plate 9) Esther's green robe isolates her and helps to focus attention upon her, as does the light red of Mordechai's robe in the *Triumph of Mordechai* (Plate 11), which is carefully differentiated from that of the flag of the Empire which is waved so prominently to the right.

Contemporary Venetian art-theorists, notably Dolce, greatly admired foreshortening and the

bravura of the *Triumph of Mordechai* must have excited enthusiasm for the horses leaping down at the spectator, a reworking and simplification of those in the *Conversion of St. Paul* (Plate 5). The soldier leading Mordechai's horse leans back in a pose that was suggested by Michelangelo's *Jonah* on the Sistine ceiling, so that we see Mordechai's head and shoulders behind him; the soldier is in shadow and the pale red of his cloak seems to focus attention on Mordechai. This is as close as Veronese ever comes to virtuosity for its own sake; in one of the three roundels that he painted for Sansovino's library in the following year (Plate 14) the pose of the soldier is repeated in the lady standing with her ledger-book but the complexity of the *Triumph of Mordechai* has been abandoned.

The other notable innovation in these ceilings is the steeply foreshortened architecture within which the figures are set with such confidence; the formula looks back to the ceiling of the Sala di Psiche in the Palazzo del Tè in Mantua which had been decorated by Giulio Romano. Giulio, however, was only able to work on a small scale compared with the very large surfaces that Veronese filled with such assurance, and the foreshortening in Giulio's ceiling lacks the unfailing certainty that we find at S. Sebastiano.

The scheme was completed by frescoes initially in the upper part of the church and then (some time later) the twelve apostles in the nave. The scheme of the upper part brilliantly complements that of the ceiling so that to the spectator in the nave the foreshortening of the twisted columns echoes that of the balustrade. Such a scheme goes back to a now lost decoration in the Mantuan Ducal Palace by Giulio Romano which had been brought back into prominence in Venice by the Rosa brothers who painted an, also lost, set of illusionistic columns on the ceiling of the Madonna dell'Orto.

That the Venetian patriciate admired these skills is witnessed by the decoration of Villa Barbaro (Plates 15–21) which Veronese completed probably in the late 1550s for Marcantonio and Daniele Barbaro (Plate 22). Both appear to have been interested in the arts; Marcantonio collaborated with Veronese on a now lost cycle of paintings, and Daniele besides producing in 1556 the edition and translation of Vitruvius that he holds in the portrait had been the author of the programme for the rooms of the Consiglio dei Dieci (Plates 7 and 8). The brothers' villa

was designed by Palladio, but they must have suggested the vaulting in the *salone* which they intended for Veronese's great suite of frescoes, where the illusionism of the slightly earlier frescoes at S. Sebastiano is developed with a new and unsurpassed richness and inventiveness. Veronese has again taken account of the direction in which the frescoes were to be viewed. Unlike the modern spectator the early visitors to the villa would first visit the nymphaeum to the north of the *Sala dell' Olimpo* where the fresco cycle begins with a lady whose attributes identify her as *Felicitas Publica (the public good)* which establishes the Barbaros' concern for the public domain; they would then walk into the *salone* (Plate 15) where they would be greeted by the lady in the centre of the ceiling riding her great snake. She is probably Thalia surrounded by the planetary gods in their normal zodiacal houses with the four elements in the fields outside the great central octagon. This frame, which is an elaborate reworking of a type that the Renaissance had developed from one of the stucco ceilings in Hadrian's villa at Tivoli, is supported on the two side walls by foreshortened twisted columns which lead down to the main cornice.

A balustrade runs around the room above the cornice and on one side a mother, nurse and small boy look at the spectator while on the other a monkey perches on the balustrade while two boys hold a book and a dog, symbols of learning and the hunt, both of which were enjoyed by the villa's inhabitants. On the walls (Plate 16) Corinthian columns set on a richly marbled dado support the cornice and frame the niches in which Peace and Faith view the ceiling; on the longer walls the columns frame landscapes which, with the exception of the crossing (Plate 19) continue on the walls of the other four rooms that Veronese frescoed (Plates 15, 18, 19 and 21).

The landscapes evoke both the foothills of the Alps where the villa is set and also a poetic vision of a romantically ruined Rome, which is a final tribute to the backgrounds of Mantegna's paintings, where a passion for archaeology is combined with a love of ruins. Five of the landscapes are based upon the views of Rome by the Flemish engraver Hieronymus Cock, a reflection of the interest of the patrons, for Daniele Barbaro had visited Rome together with Palladio. Where Cock accurately records the ruins in their contemporary settings Veronese replaces the modern buildings with an imaginative series of ruins; the changes indicate that the

landscapes which relate to engravings by another artist from Verona, Battista Pittoni, do not derive from the engravings but served as Pittoni's inspiration.

Landscape had long played an important part in the decoration of Renaissance villas but those at Maser recall in their range – with harbours, ruined theatres, palaces, villas (including a distant view of Maser in the *Sala dell' Olimpo*) and small figures going about their work – Pliny the elder's (AD 23-79) description of the landscapes of Studius: 'He introduced a delightful style of decorating walls with representations of villas, harbours, landscape gardens, sacred groves, woods, hills, fishponds, straits, streams and shores, any scene in short that took the fancy. In these he introduced figures of fishers, or of fowlers or of hunters or even vintagers. He also brought in the fashion of painting seaside towns on the walls of open galleries, producing a delightful effect at very small cost.'

The invention that marks out the landscapes is also found in the frames in which they are set; the scheme has its origin in now destroyed frescoes by Giulio Romano recorded by an anonymous Flemish visitor to Mantua in the sixteenth century (Fig. 5). Veronese has given greater depth to his wall, introduced a greater range of textures with coloured marble, cameos and swags and varied both the orders between the rooms and also the way in which the columns frame the doors and windows. There is a splendid series of jokes including the apparent curve to the frame of the wall in the Stanza della Lucerna (Plate 17), the mock classical statues to the sides of the landscape in that room and the small painted portraits that we appear to glimpse next to a statue in the Stanza di Bacco (Plate 21).

The rich profusion of this invention is linked with a programme: Daniele Barbaro wrote in his annotation to chapter V of Book VII of Vitruvius that: 'Painting should have an intention and represent an *effeto (effect)*, and all the composition should be based on the *effeto (effect)*, and like fiction painting should be useful and like music it should have a design.' In the *Sala dell' Olimpo* we have already noted the planetary gods in their zodiacal houses surrounded by the four elements with a lady riding a snake in the centre; the Renaissance concept of the harmony of the spheres would link together these disparate figures, provide a reasonable identity for the lady in the centre (Thalia, the ninth muse) and connect the room with the

Fig. 6 *The Last Judgement*
Tintoretto
VENICE, Madonna Dell'Orto.

eight ladies in the crossing (Plate 19) whose musical instruments thus identify them as the remaining muses.

The Barbaros would have been well familiar with the idea that the musical harmonies are in-born in man because they reflect the harmony with which the planets move. The great Florentine neo-Platonist Marsilio Ficino (1433-99) had, at the end of the fifteenth century, attempted to correlate the nine musical modes with the seven planets and this was taken up by Francesco Gafurius at the beginning of the sixteenth century, who had added an extra planet and subtracted one of the muses (Thalia) to get the scheme to work.

Veronese's version of this subject is infinitely more successful and classical than the rather charming woodcut that accompanied Gafurius' *Practica Musice* of 1518; it is not the only theme in the room, let alone the villa, but it had the attraction of being a general *effeto (effect)* of the type that Barbaro demanded for painting. This same complex of ideas is further reflected in the ceiling in the Stanza di Bacco (Pl. 20) where Bacchus presses grapes into the bowl raised by the Lares, accompanied by their dogs. His dual role as god of wine and as leader of the muses and of music is underlined through the muse serenading the reclining figure of sleep.

In his brilliant realization of this complex programme Veronese drew upon a wide range of sources. The grouping of the Planetary gods and Thalia suggest the influence of Correggio's cupola of the *Vision of St. John the Evangelist* in S. Giovanni Evangelista, Parma, where there is a comparable break between the foreshortened apostles and the central figure. The individual figures both here and in the rest of the villa reveal the influence of the antique as it had first been interpreted by Raphael; the connection with Raphael is important both for individual motifs and also for the elegant restraint with which Raphael approached the antique, which had been abandoned by the younger generation of central Italian artists in their search for *maniera*.

The combination of a relief-like grouping with rolling clouds in the lunette of Venus and Vulcan (Plate 16 at the top) recalls Raphael's *Marriage Feast of Cupid and Psyche* in the Farnesina, Rome, although Veronese avoids the illusion of a tapestry and where he re-used the scheme on a ceiling (Plate 20) was prepared to foreshorten the figures. Both the Venus on the ceiling of the Sala dell' Olimpo and the Providence derive from the Grace with her back to the spectator

in Raphael's Farnesina lunette of *Cupid with the Three Graces*, although Veronese also reveals his knowledge of the antique *Crouching Venus* that inspired his immediate prototype. This knowledge of the form of the Roman gods is combined with an instinctive feeling for the correct mood for the figures. The rather grumpy Neptune on the ceiling of the Sala dell' Olimpo is accompanied by a playful putto lifting a huge shell, while another plays with one of Juno's birds tied to a piece of string. Venus in the centre of the ceiling has confiscated Cupid's bow and arrows and has made him write out his alphabet, Diana caresses one of her dogs who places an affectionate paw in her lap and Mercury holds his caduceus, the symbol of his eloquence. At his feet a putto holds an astrolabe which indicates Daniele Barbaro's interest in astronomy, which he was careful to distinguish from astrology which he believed to be meaningless.

We have no direct comment upon Maser by either of the patrons (and Palladio also fails to mention the decoration in his account of the villa in the *Four Books of Architecture* of 1570) but later they are said to have recommended Veronese for a share in the decoration of Sala del Maggior Consiglio in the Ducal Palace that was destroyed in the fire of 1577. We can get an indirect measure of Veronese's success from the passage in Daniele's edition of Vitruvius, in which he notes that painters should be skilful in elegant poses and foreshortening, graceful outlines (*contorni*) flesh painted softly (with *morbidezza)*, the proper expression of mood rank etc. and differentiation between male and female nudes. These terms were the common currency of Venetian critical thought of the late 1550s but looking back at Villa Barbaro we see this, and much more, in Veronese's frescoes.

It is not surprising that Daniele Barbaro should choose to have his portrait painted by Veronese (Plate 22). Barbaro had been painted by Titian about ten years earlier and he might well have agreed with a later visitor to Venice, Sir Philip Sidney, who wrote in 1574 about the decision to have his portrait painted saying that he was undecided between Tintoretto and Veronese: 'who hold by far the highest place in the art.' The choice went to Veronese and a year

later one of Sidney's friends wrote about that, now lost, portrait: 'The painter has represented you a little sad and thoughtful.' This is the mood that is captured in the portrait of Barbaro, probably painted around 1556, where the learned cleric is shown seated at a table holding open various pages of his 1556 edition of Vitruvius. The column to the right is a further indication of his interests, but one that is not allowed to distract from the sitter. Although there is little new in this or the other portraits by Veronese, he handles the accepted formulae with skill and sensitivity to the sitter, although there is a considerable range from the use of attributes here and in the *Portrait of Alessandra Vittoria* (Plate 55) to the straightforward presentation of the unidentified woman in *Portrait of a Woman* (Plate 23) where the precision of the costume is combined with a feeling for her presence. The sculpture on the marble base and the view of St. Mark's in the distance must once have identified the now anonymous *Portrait of a Man* (Plate 24). His casual *contrapposto (twisting movement)* as he leans against the ledge from which spring the twin columns framing the statue must have influenced Rubens' Genoese portraits.

The support and interest of Daniele Barbaro may also have been important for the growth of Veronese's interest in brocades and rich fabrics that become such a feature of his paintings in the 1560s. The usual perspective in which Venetian critics viewed Renaissance painting was one of progress, derived from Giorgio Vasari's (1511-74) *Lives of the Artists* of 1550; poor old Giovanni Bellini got so far before being overtaken by Giorgione and Titian. The manuscript of Daniele Barbaro's *Treatise on Perspective*, published in 1569, included a passage which although it did not find its way into print, suggests that he did not altogether share this view. In his discussion of the vanishing point he states that as a general rule it should be on a level with the heads of the main figures; it can be higher when the things shown are lower than the level from which they are viewed, as in Bellini's lost *Naval Battle*, or when it is the reverse it can be lower, as in Mantegna's Eremitani chapel frescoes in Padua.

Barbaro's mathematical interests led him to admire a type of painting which others had found outdated; Veronese must have been predisposed to share this view since he was himself

interested in Mantegna. One other factor may have influenced the rich sunlit brocades that we find in the saints on the outside of the organ shutters from S. Geminiano (Plate 27) of 1558 to 1561; Dolce, writing in 1557, had commented on the monotony of the graceful mannerist style, and Veronese may have turned to the tradition of Bellini and Carpaccio as a way of avoiding the pitfalls of the current central Italian style.

Those other great organ shutters, which were added somewhat belatedly to the upper nave of S. Sebastiano (Plate 28), illustrate the skill with which Veronese paints in the style advocated by Daniele Barbaro. The viewpoint of the *Presentation of Christ* is low and the blending of painted pilaster and real Corinthian column reflects the link that Mantegna had established in the S. Zeno altar in Verona. The colonnade that runs behind the figures when the shutters are open for the *Pool of Bethesda* reflects the painted cornice that runs behind the figures in the Mantegna; just as the forms that Veronese employs betray his awareness of the current architectural vocabulary, so his figures are painted with a breadth and fluency that we find in the sixteenth but not in the fifteenth century.

The composition is a good example of the skill with which he reconciles the demands of narrative with an interest in rich effect. The figures are composed in a deep frieze-like grouping, which is maintained in the front plane; the great curving arch that frames the figures is masked at its lower springing so that the apparent depth of the building is denied. Veronese achieves a flowing rhythm through the line of heads which, like the glances of the attendants, focuses attention upon Christ, who is set off by the brilliant blue of the Virgin's robe which is the main accent of the colour in both canvases.

While the compositional devices of the *Presentation of Christ* recur in the Turin *Feast in the House of Simon* (Plate 29), in the *Martyrdom of St. Sebastian* (Plate 38) and in the great series of the *Adoration of the Magi* (Plates 47 and 48) it is, perhaps, difficult not to agree with Sir Joshua Reynolds' (1723-92) classification of Veronese as a decorative painter, when faced with the *Marriage Feast at Cana* (Plate 32). In his *Fourth Discourse* of 1771 Reynolds chided Veronese as

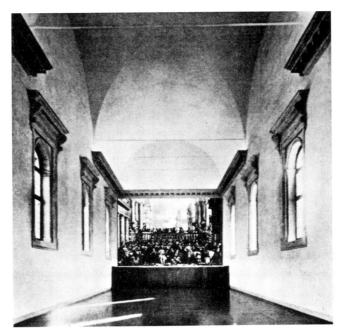

Fig. 7 Photomontage of the *Marriage Feast at Cana* in the refectory
of S. Giorgio, Maggiore Venice

follows: 'The subjects of the Venetian Painters are mostly such as give them an opportunity of introducing a great number of figures. I can easily conceive that Paul Veronese, if he were asked would say that no subject was proper for an historical picture, but such as admitted at least forty figures; for in a less number, he would assert, there could be no opportunity for the painter's showing his art in composition, his dexterity of managing and disposing the masses of light and groups of figures.'

Reynolds would have been surprised to find that his heroes, the Carracci, greatly admired Veronese who played a crucial part in the development of Annibale Carracci's style in the 1580s. Blinded as he was by his dislike of the contemporary Venetian revival of Veronese, he failed to appreciate that the 'managing and disposing of the masses of the light' plays an integral part in the narrative. This can be appreciated by looking at the photomontage which (Fig. 7) replaces the picture on the end wall of the refectory of S. Giorgio Maggiore under

Palladio's great cornice. This cornice is echoed in the balustrade in the centre of the canvas, above Christ's head, which cuts off the sixty or so guests in the foreground from the servants behind. It also shows how the rich marble Doric columns in the foreground with their entablature topped by a balustrade do not echo the line either of the cornice on the long walls or of the windows. The break with the real space of the room, which is caused by placing the vanishing point of the architecture in Christ's head, draws attention to three groups in the foreground: the small page on the left who offers a glass of wine to the host of the Feast watched by a grand servant with his foot on the step and another who rests from pouring; the group of musicians in the centre (Plate 33) dominated by Christ; the servant in the beautiful brocade standing contemplating a glass who is behind a servant pouring out the water and in front of the monks, who are in shadow.

The traditional way of showing the miracle in the *Marriage Feast at Cana* is by emphasizing the servants pouring great stone jugs of water into elegant wine pitchers. This moment, John 2, 1–10, was retained when in the sixteenth century the *Marriage Feast at Cana* became isolated from cycles of the life of Christ as a subject for a refectory. Because of the scale of his painting Veronese has combined this moment with the slightly later one: 'And he (Christ) saith unto them, Draw out now and bear unto the governor of the feast. And they bare it. When the ruler of the feast had tasted the water that was made wine and knew not whence it was: (but the servants which drew the water knew)'.

The servants in the foreground invite the spectator to share their wonder at Christ's miracle and the musicians, who include Veronese and Titian, must be understood as celebrating Christ's power. This awareness of the miracle fills the foreground while the superb detail – guests wiping their faces with their napkins or picking their teeth – is in the background, a background whose importance is diminished by setting the recession of the tables higher than that of the architecture, above the head of Christ.

Critics are often tempted (understandably) to compare this vast canvas with the theatre and there is indeed something theatrical in the modern sense about the richness of the costumes

and setting. It is, however, a mistake to claim that the Renaissance theatre helped Veronese visualize this scene for the sixteenth century saw the development of two traditions of theatre design, neither of which appears relevant to the *Marriage Feast at Cana*. The Roman architect Peruzzi and his follower Serlio designed elaborate illusionistic settings according to the nature of the play (tragic, satyric or comic) which are more concerned with recession than the setting of the *Feast*; the alternative tradition was embodied in Palladio's *Teatro Olimpico* in Vicenza where the action is set in front of a *frons scenae* reminiscent of a triumphal arch. Neither tradition influenced the *Marriage Feast at Cana* where the massive columns which frame the figures open onto a vista of sky in a way which influenced baroque stage design, notably that of the Venetian Giacomo Torelli; it is because of this influence that Veronese's works appear to us theatrical.

The style of the *Marriage Feast at Cana* marked a return to the Venetian tradition of Bellini and Carpaccio; its appeal was not confined to a Venetian clientele for the *Omnia Vanitas* and the *Honor et Virtus Post Mortem Floret* (Plates 41 and 42) were probably commissioned for the elector of Bavaria, Albrecht V, in 1567. These canvases, in the Frick Collection, New York, together with a number of outstanding mythological paintings (Plates 43 and 44) share the rich costumes, warm light and frozen movement of the *Marriage Feast at Cana*; the Frick paintings differ from the others in their programme, which is proclaimed by the inscriptions on the canvases. Christian Truth's faith in God is contrasted with the world's baubles, and with the melancholic gaze of Hercules whilst the young man who must (following the inscription) be Honour, embraces Virtue and flees from death on the left with nothing worse than a tear in his stockings. The pictures demand a specific context, unlike the other canvases, which may have been the marriage of Albrecht's son and subsequent heir, Wilhelm V, which the Bavarian court celebrated with ostentatious expense in 1568.

The Frick paintings share the classicism of Maser, where the planetary gods are based upon Roman models, most notably in the figure of Hercules who is based upon the famous Roman Hercules in the Farnese collection, Rome. Mercury in the *Mercury, Herse and Aglauros* (Plate 52) derives from a well-known Roman type both in his figure and attributes, the winged hat and

caduceus; the picture shows the climax of the story in Ovid's *Metamorphoses* where the jealous Aglauros tries to stop Mercury from visiting her beautiful sister Herse, and he turns her to stone. The choice of moment has suggested a series of visual puns; Mercury and Aglauros resemble a group of sculpture, but sculpture whose life is underlined by setting them in front of the statue in the niche.

The sense of tragedy is lost in the richness of the setting (itself suggested by Ovid's text) and the restrained gesture with which Herse witnesses her sister's fate; this same cheerfulness recurs in the *Mars and Venus Bound by Cupid* (Plate 43) in New York where Venus is shown after bathing, her robe hung over the bower behind her while Cupid joins her to Mars. Venus presses her breast and the milk that spurts as a symbol of the fertility of their union is echoed by the water running from the lion's mouth; Venus smiles down on Cupid as he ties the lovers together and another putto bears off the sword that Mars will not need for some time. This cheerful mood also prevails in the potentially much more erotic small *Mars and Venus* (Plate 44) in Turin; at last both lovers are undressed (itself rare in Veronese) but they are interrupted by Cupid leading Mars's amiable horse down the steps to peer into the room.

The defeat of the Turkish navy by the Holy League at the Battle of Lepanto on 7 October 1571 was a cause for celebration throughout Christendom, more especially for the Venetian republic, as it laid to rest 'the myth of Turkish invulnerability.' In 1572 the funeral oration of the official state orator, Paolo Paruta, compared the Venetians' victory with those of the Greeks over the Persians and of the Romans over the Carthaginians. Turkish power was not broken and in 1573 Venice was forced to cede the Kingdom of Cyprus to the Turks, although retaining their command over another great Mediterranean island, Crete. These events may have prompted the choice of subject for two mythological paintings, the *Rape of Europa* (Plate 45) of 1573, commissioned by Jacopo Contarini, whose knowledge of history meant that in 1577 he was one of three patricians, chosen to plan the redecoration of the Sala del Maggior Consiglio, and the *Family of Darius before Alexander* (Plate 53), which is undated but is agreed to be close to the *Rape of Europa*.

The *Rape of Europa* (Pl. 45) is a faithful rendering of book II of Ovid's *Metamorphoses*, where Jupiter ordered Mercury to drive the king of Tyre's herd of cattle down to the shore where Europa, the king's daughter, was playing with her maidens. Jupiter then:

> 'took the form of a bull... and when her (Europa's) fear has little by little been allayed, he yields his breast for her maiden hands to pat his and his horns to entwine with garlands. The princess even dares to sit upon his back, little knowing upon whom she rests'

One of Europa's companions attends to the princess, while another looks up at the putti sweeping down with the garlands of roses, which they are picking from the trees, and the startled expression of the cow on the right suggests the surprise of the king's herd. The pyramid establishes the setting in Phoenicia, but Jupiter leads Europa down to the sea and thence to his native Crete. This is not clarified in Ovid, but Jupiter represented Crete in Venetian propaganda, well known to Contarini.

The imposing setting and choice of emphasis in the *Family of Darius before Alexander* (Plate 53) may celebrate the Battle of Lepanto, and more especially the achievements of one of the Pisani for whom it was commissioned. Following Alexander's defeat of Darius, the Persian king's family has been abandoned to the mercy of their conqueror in Darius's castle (*castrum*). In the absence of Darius's mother, mentioned in the sources, his wife kneels before the imposing soldier she takes to be her conqueror pleading for her vulnerable daughters, the oldest of whom wears golden bridal costume. Although her entreaties are seconded by a bearded councillor, she has picked the wrong man and addressed Hephaestion, bare-legged but wearing contemporary parade armour. Alexander, singled out by his splendid red cuirass, spares the queen's embarrassment by indicating that Hephaestion is a second Alexander. The horse, dog and page in Alexander's suite watch the drama as do the Persian servants together with a dwarf, carrying the crowns of the royal family, whose captivity is symbolised by the chained monkey.

That Jacopo Contarini and the Pisani chose to decorate their palaces with major paintings marked an important stage in a significant development. At the end of the fifteenth century paintings had not played a major role in the decoration of Venetian palaces. The turn of the century saw demand for Giorgione's cabinet paintings, intended for a relatively restricted studio. These helped to develop a concern for artistic skill, at the expense of costly materials, which had been Venice's major priority until the middle of the sixteenth century, with the commission for the ceiling paintings in the rooms of the Consiglio dei Dieci (Council of Ten) (Plates 7 and 8). By 1570 large paintings were ordered in sets of four – often of the seasons – to be hung in the *camere grandi*, the large communal space on the first floor of Venetian palaces. Alvise, Zuanantonio and Antonio Coccina sealed this pattern with their commission in 1571 for Veronese's cycle of the *Coccina Family presented to the Holy Family*, *Adoration of the Magi*, the *Wedding Feast at Cana* and the *Christ Carrying the Cross* for their newly built (1563) palace on the Grand Canal (Plates 46 and 47). It was soon followed elsewhere in Venice, in the four canvases devoted to the zodiac produced by the workshop in 1580 to accompany the new gilt leather hangings in the Sala delle Pitture of the Fondacho dei Tedeschi, but destroyed in Berlin in the last war, and, through the intervention of Francesco Barbaro, by Charles Emanuel of Savoy in the *Queen of Sheba before Solomon* (Plate 66)

With the *Four Allegories of Love* in the National Gallery, London this was extended to ceiling decoration (Fig. 11). Nothing is known of the commission of the four paintings, which were first recorded in Prague inventories of the collection of Rudolph II (Holy Roman Emperor 1576-1612). Since Rudolf was unmarried, the ceiling was probably originally intended for a Venetian in celebration of a marriage and dates from the early 1580s. They were probably displayed down the centre of an exceptionally large room, perhaps in the sequence shown in the preparatory drawing in the Metropolitan Museum of Art, New York. At the top of that sheet the woman in her beautiful, but not too revealing, brocade dress kneels before Fortune on her globe, holding the olive branch with the soldier, a cloak thrown over his armour. Their future faithfulness is suggested by the dog at their feet, while the putto imposes Love's chains on the woman. This contrasts with *Disgust* a land of lust – the pipes held on the right edge and the

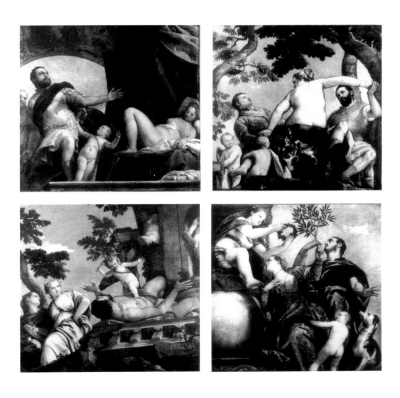

Fig 8 *Four Allegories of Love*, Paolo Veronese, London, National Gallery, each 187 x 187 cm.

legless Pan – whose corroding civic effects are shown in the fallen classical entablature. The lustful man is chastised by Cupid as he lies on his back, naked except for a convenient drapery, while his companion, wearing a low cut dress, has to be restrained by Chastity.

Further down the sheet in *Unfaithfulness* the woman, seen with her beautifully foreshortened back sitting on an elegant brocade, slips a note (Ch. mi. p[osede] (who possesses me) to her new, younger, lover. Her military companion is caught with his trousers down, a yellow cloak hiding his embarrassment, as the winged Cupid, looks disapprovingly away from his clavichord. In the contrasting *Respect* it is the turn of the woman to embody vice, perhaps drunkenness, as she lies asleep in naked abandon – with an empty glass beneath the bed. Here the chain of love hangs from the bearded soldier's cuirass to the handle of his sword, sheathed in spite of Cupid's urgings.

The range of allusion found in the mythologies is repeated in the religious paintings where they link with some of the major religious movements of the period. The S. Zaccaria altar (Plate 34) of the early 1560s echoes Bellini's altar in the nave of the church in the decorated

pilaster, the strip of sky to the left and the richly ornamented cloth of honour behind the Virgin. The composition is a variation on that of the S. Francesco della Vigna altar (Plate 3) which shows a greater command of the brush in evoking a wide range of textures; both the gestures and the colour link the saints more closely with the Holy Family, and this emphasis comes into focus the picture as was commissioned by Francesco Bonaldi and commemorated Jerome and John Bonaldi.

By contrast the saints in the main altar of S. Sebastiano *The Virgin and Child appear to SS. Sebastian, John the Baptist, Peter, Catherine and Elizabeth?* (Plate 35) are thrown into shadow by the brilliance of the heavenly vision of the Virgin and Child accompanied by music-making angels. The contrast between the saints in shadow and the Holy Family in the light, which is not found in the picture's source, Titian's altar from S. Nicolò now in the Vatican, Rome, establishes a set of priorities for the saints through whom the spectator experiences the vision, which links with one aspect of the Council of Trent's decree on the veneration of saints and their images.

This devotion had been challenged by Luther in 1522 and his call to ban images from churches was eagerly taken up by the Calvinists, through whose influence it began to take effect in France in the early 1560s and the Netherlands from 1566. Calvinist iconoclasm, which was hardly an issue in Italy, was only brought to the attention of the Council of Trent in November 1562 through the intervention of the French who wanted a policy of accommodation with the Calvinists. The Council's decree issued on the 3rd of December 1563 followed closely a slightly earlier French document in its emphasis on the images of saints as exemplars, to be followed by clergy and congregation alike. But the decree also reaffirmed that the invocation of saints was not idolatrous: 'but good and useful because their intercession is effective through Christ our only redeemer and saviour.'

The devotion of saints was a relatively small item in the wide range of practical issues covered in the Council's decrees. Reform of the clergy was a major concern and they strengthened the authority of bishops, who now had to visit their dioceses regularly. This and the reforming activities of a new breed of bishops and priests resulted in considerable

redecoration of Venetian churches with lavish display of new altars and ceilings, notably the *Crucifixion* and the *Baptism of Christ* (Plates 63 and 64), which formed a part of the redecoration of S. Nicolò ai Frari. There was a comparable combination of new controls and regular attendance at church rituals for both the religious orders and the confraternities, lay associations which dated back to at least the thirteenth century.

Veronese would have been well informed about the Council's proceedings for as patriarch elect of Aquileia, the costume in which he is depicted in his portrait (Plate 22), an older see than that of Venice, Daniele Barbaro had played an important part in the Council's considerations in the early 1560s. The *Virgin and Child Appearing to SS. Anthony and Paul* (Plate 30) of early 1562 shows why he was responsive to this aspect of the decree. The saints are usually shown alone in the wilderness and there is no literary source for the appearance of the Holy Family; the contrast between the shadow of the earthly sphere and the light of the heavenly vision, the low viewpoint and St. Anthony's rapt devotion anticipate the saint's role as intercessor which finds its fullest expression in the great *Martyrdom of St. George* (Plate 39) most probably painted in 1566. The attendants, the horsemen, the priests and the idol are traditional elements which are grouped around the saint so that they do not distract from his still prayer as he ignores the priest urging him to worship Apollo. St. George's plea as he looks up to the heavens is received by the Holy Family through the intercession of SS. Peter and Paul together with Faith, Hope and Charity, while an angel carries down the martyr's palm and laurel.

The emphasis upon the saint as intercessor breaks with the tradition both for St. George and for other saints and establishes a new type of martyrdom that Veronese re-used in the *Martyrdom of St Justina* (Plate 51) and which influenced artists as different as El Greco and Elsheimer. The, comparative, peace and stability of Italy in the 1560s, which contrasts with the religious persecution and martyrdom of both Catholic and Calvinist common in the rest of Europe, helps to explain why the calm stillness of the saint in *Martyrdom of St George* (Plate 39) is so very different from the bloodshed and torture found in later paintings influenced by the decree of the Council of Trent, but which reflect the sufferings of the Jesuit order.

The calm security of late sixteenth century Venice is suggested by the *Mystic Marriage of St. Catherine* (Plate 36) where the red drapery around the twin columns and the saint's beautiful brocade with a pattern of gold, blue and yellow on white convey a festive mood, which is taken up by the choir of angels accompanied by the lutenists. This celebration of the saint's vision (the basis for the subject), and the burst of golden light in which the martyr's crown and palm are borne down draw the spectator to share in the mystic marriage.

This view of Veronese as an artist responsive to the spirit of Catholic reform embodied in the Council of Trent must appear difficult to reconcile with his appearance before the inquisition on 18 July 1573 to answer a series of questions about the *Feast in the House of Levi* (Plate 50). Most modern scholars believe that the original subject of the *Feast* was a *Last Supper* both because this was the subject of the Titian which it replaced and because the text refers to it as an: 'ultima cena' (last supper). The text is not an exact transcript of what was said but a shorthand précis of the proceedings and it seems unlikely that it was ever intended as the same subject as the (admittedly later) *Last Supper* (Plate 70). One of Veronese's first replies when asked whether he knew why he was there was: 'I was told by the Reverend of the Fathers, that is the Prior of SS. Giovanni e Paolo, whose name I do not know, that the inquisition was here and that you illustrious gentlemen had ordered me to paint the Magdalen in place of a dog, and I had replied that I did not think that a figure of the Magdalen could be added convincingly'. The Magdalen anointing Christ's feet is the central moment in the *Feast of the House of Simon* (Plate 29). We can speculate that since Veronese had already painted three *Feasts in the House of Simon* with this scene (two quite recently in Venice) the original contract, which has not come down to us, may have called for him to vary his treatment of the theme, which would explain the intervention of the inquisition.

That remains guess-work; but his appearance contains a coherent defence of the painting in terms of its decorum that modern critics appear to have overlooked in their emphasis on Veronese as an unlearned painter. When he was questioned about the servant wiping his nose and the soldiers he argued: 'the patron of the house was, as I have been told, grand and rich

and should have such servants' (such a host plays no part in the Gospel account of the *Last Supper* but is central to the *Feast in the House of Simon*). When the subject arose again Veronese strengthened his case by observing that the offending figures are: 'outside the place where the feast is held'.

The triple division of the canvas by the Corinthian columns and the smaller arched opening echoes the division of the cornice; Christ in the centre of the canvas is emphasized by making the central arch wider than those at the side and by being the only figure framed by the sky (the others are set against the distant view of a city). Some servants are inside the main part of the building, but the figures to whom the inquisition objected, are either in front of the columns or on the stairs that lead to the central opening, a device that he had first used the year before in the *Feast of St. Gregory the Great* (Plate 49).

Veronese had compensated for the omission of the Magdalen by contrasting Judas's lack of faith with the conversion of the servant in the striking brocade, whose intense gaze and still pose invite us to share his recognition of Christ the saviour. Judas turns away from Christ as the servant draws his attention to the dog, suddenly aware that the cat under the tablecloth is playing with a bone. This finds no place in Veronese's testimony, whose failure to mention that the handkerchief and bloody nose of the servant on the stairs are a low-life allusion to Christ's sufferings does not mean that they should be treated simply as genre figures, although these were also included -notably in the exotic falconer with his hooded Lanner falcon, a motif suggested by Vittore Carpaccio's *Arrival of the English Ambassadors* in the St Ursula cycle, now in the Gallerie dell' Accademia, Venice.

At the end of Veronese's appearance it was noted that he should: 'change the painting so that it would be suitable as an *Ultima Cena*.' This did not happen; instead, by a compromise not suggested in the text, the title was changed to that of the *Feast in the House of Levi* with whose action as described in St Luke's Gospel it hardly fits for no scribes or pharisees rebuke Christ.

One of those entitled to sit on the tribunal with the inquisitor was the Patriarch of Venice, since 1560 Giovanni Trevisan, who later in the decade commissioned the *SS. Peter and Paul John*

Evangelist (Plate 59) for his church, S. Pietro in Castello. This fact alone shows the consideration which Veronese continued to enjoy among the influential patriciate in Venice some of whom must have worked for the compromise adopted in the *Feast*.

As befits an altar commissioned by Giovanni (John) Trevisan, St. John is placed above SS. Peter and Paul; the saints are not set in an architectural framework but in a romantic landscape, and the aura of mystery is heightened by the sombre tonality and by the angel appearing in a burst of light to St. John who holds aloft the chalice, one of his attributes. The picture has been transformed from the conventional *sacra conversazione* (in English term for a painting with a group of saints, generally grouped around the Virgin and Child) by the memory of Carpaccio's *Agony in the Garden* in San Giorgio degli Schiavoni, Venice; the change may well have been prompted by the Catholic defence of the Sacrament of the Eucharist which had been challenged by Luther's view that it was only a sign, that Christ was not present and that the Sacrament should not be adored. The reaction had begun in Milan in 1527 with the non-liturgical worship of the Host in the services of benediction, in the forty hours' exposition, which was much popularized by the Capuchins and Jesuits and which was fully endorsed by the twenty-third session of the Council of Trent.

The devotion shaped the planning of Tintoretto's decoration in the Sala Grande of the Scuola di S. Rocco in the later 1570s and influenced a number of other paintings by Veronese including the *Doge Sebastiano Venier's Thanksgiving for the Battle of Lepanto* (Plate 57) where the chalice held by Faith is placed prominently under Christ's left foot. It must also have played a part in the choice of subject (and of its treatment) for the main altar of the church of S. Giacomo (St. James), the *Christ with Zebedee's Wife and Sons* (Plate 60). St. James, shown with his pilgrim's staff, is in the centre of the canvas, while his mother presses the suit for her children to sit on Christ's left and right and he enquires: 'Are you able to drink of the cup that I shall drink of, and to be baptised with the Baptism that I am baptised with?'

The Eucharistic chalice borne high above the altar by the two angels and blessed by God the Father anticipates the elaborate settings for the non-liturgical worship of the Host developed

early in the seventeenth century. The devotion also influenced the *Martyrdom and Last Communion of St Lucy* (Plate 73), commissioned for the Confraternity of the Cross at Belluno. The *Martyrdom and Last Communion of St Lucy* departs from Altichiero's frescos in the Oratory of S. Giorgio, Padua, which Veronese would have known. These show the saint's triumphal resistance to a team of oxen in the foreground and her communion in a distant loggia. Veronese represented St. Lucy's martyrdom with the kneeling saint, stabbed to death in her bosom, her arms outstretched but gazing not at the heavens but at the communion wafer held by the priest on the right, while the details of her torture are relegated to the background.

The brooding character of the *Martyrdom of St. Lucy* is exaggerated by its rubbed condition, but, like many late Veronese's it was thinly painted, probably as a response to the sketchy quality of late Tintoretto. It is one of a number of paintings which reflect Tintoretto's influence, through which Veronese learned to vary the style of his work according to the subject matter. The attendants, the elegant steps on which the saint is posed and the rich brocade of the robe in the 1575 *Martyrdom of St. Justina* (Plate 51) continue the style of the 1560s; the light effects in the upper part where the dark figures of the Dëesis (Christ, Mary and St John the Baptist) are contrasted with the burst of light behind them look back to Tintoretto's *Last Judgement* in the Church of Madonna dell'Orto, Venice (Fig. 7).

The commission in 1583 to paint an *Annunciation* (Plate 65) for Philip II of Spain must have recalled his patronage of Titian and the dramatic gesture with which the angel greets the Virgin looks back to Titian; but the setting with its balustrade, God the Father appearing with the heavenly host in the burst of light show Veronese's independence, as does the colour with the flickering yellow highlights on the angel's pale pink costume. The *Judith* (Pl. 69) underlines Veronese's responsiveness to the half-length format, which he adapted from the *Judith with the Head of Holofernes*, now in the Musée des Beaux-Arts, Caen, which had formed one of a set of four paintings of Old Testament heroines commissioned in 1582 by the heirs of Francesco Bonaldi (d.1577), responsible for the *Holy Family Enthroned with SS. John the Baptist, Francis, Jerome and Justina* (Pl.34). Judith is realised with dramatic movement as she prepares to hand Goliath's

giant head to the servant. This, together with her defiant glance and the directness of the view-point, emphasise her heroism and offset her beauty and the finery of her costume and jewellery.

For the King of Spain Veronese used the more 'public' style that is found in the contemporary *Queen of Sheba before Solomon* (Plate 66) and in the later work in The Ducal Palace, Sala del Consiglio and the Sala del Collegio (Plates 56–58) which had been ravaged by fire in 1574 and again in 1577; it was as a result of this latter devastation that the Sala del Maggior Consiglio had to be redecorated with the grandiose series of ceiling paintings which culminated in the *Venice Triumphant* (Plate 58) above the Doge's throne. According to a late, but reliable, tradition the three members of the commission responsible for the scheme had to approach Veronese to undertake the work. This is plausible both because of the amount of work that he appears to have had in hand and because of the freedom that he was allowed. The manuscript with the commissioners' scheme has survived, and, while Veronese has fulfilled the demand for the figure of Venice: 'enthroned in imitation of Rome seated on the globe crowned by Victory' the allegorical figures no longer accompany Victory but sit at Venice's feet. The allegories follow closely those of the scheme, but the four putti who represented the four seasons have been abandoned; instead the idea of the contentment of the people is realised in the crowd behind the balustrade looking up at Venice. The soldiers and their captives who are not mentioned in the scheme, must have been included by the artist to fit with the other paintings of the ceiling.

The scheme makes no mention of the magnificent setting with the great foreshortened triumphal arch and twisting columns which, together with the rich contrasts of light and shade, show the development since the ceilings of St. Sebastiano (Plates 9–12). The crucial change, that the space is defined by the architecture rather than by the figures, had first occurred in the *Assumption of the Virgin* (Plate 40) completed by 1564. In its energetic gestures and in the red of the Virgin's mantle trailed by the angels and set off against the golden heavens it reflects Titian's *Assumption* in the Frari, Venice, but the virtuoso architecture suggests a transposition of one of the bays of the Sistine ceiling seen by the spectator with his back to one of the long walls in the

chapel. The Evangelist in the foreground has replaced the prophet and the steps and balustrade leading to the sarcophagus equal the prophet's throne; the remaining apostles are in the position of the ignudi with the Virgin and her attendants substituted for the central history.

The growth of Veronese's response to the text can be seen in the late *Crucifixion* (Plate 63) where the dark skies, which dominate the canvas, are offset by the pale women framed by the rearing horse, an interlude that underlines that Christ is the focus of the colour and the light. The gestures underline Christ's primacy and the incidental details, the dead rising from the grave, the spectator fleeing in terror, are in the shadowy foreground. The choice of Matthew 27, although not without precedent, must have been made to contrast with Tintoretto's huge *Crucifixion* in the Sala dell'Albergo of the Scuola di S. Rocco. Veronese's great altar inspired a number of versions of which the most dramatic is the superb *Crucifixion* in Budapest (Plate 72); although not a narrative picture it conveys great emotion through the deep greens of the sky which set off the glittering aureole around Christ, whose head falls forward at the moment of death.

The intensity of these religious paintings recurs in the late mythological paintings, the *Venus and Adonis* (Plate 67) and the *Cephalus and Procris* (Plate 68), for instance. They were painted as a pair in the early 1580s and while this is not the first example of this practise, see the *Omnia Vanitas* (Plate 41) and the *Honor Et Virtus Post Mortem Floret* (Plate 42), Veronese uses the contrast to establish a pessimistic view of life. The pictures complement each other with framing trees to left and right, in the figure groups – in one the young man lies in the woman's lap in the other the woman is cradled by the man – and in mood. Although darker than the earlier mythologies, the pale red of Adonis's costume establishes the mood for the lover's idyll which contrasts with the dark shadows in the *Cephalus and Procris* which echo the tragedy of the story. The choice of subject underlines these contrasts, for Venus warns Adonis of the dangers of hunting, dangers that are embodied in the tragedy of Procris's death at the hands of her huntsman husband.

The simplification of the landscape and the sombre range of subdued greens recur in the

Christ with the Woman of Samaria (Plate 78) which is probably one of Veronese's last paintings. The drama of Christ's long dialogue with the woman of Samaria is expressed by his outstretched left hand as he asks her to draw water for him; the Apostles in the centre of the canvas on their return do not distract from the calm eloquence of the foreground figures. The simple settings of these canvases contrasts with the more complex landscape of the near-contemporary *Baptism of Christ* (Plate 64) which combines the Baptism with the Temptation which follows it in the Gospels; the complex thick woods on the left and the exposed middle ground on the right (all of which were to influence Annibale Carracci) suggest the desert far from Jerusalem whose appearance above the trees in the background is crucial for the Temptation.

Veronese died in April 1588 and it is perhaps no accident that two of his last paintings should be concerned with divine healing; the saint in the *St. Pantaleon Heals a Sick Boy* (Plate 76) turns and looks up at the angel through whose power he has just driven out the small demon from the sick boy held by the parish priest. The saint is emphasized both by the pyramidal grouping and by the brilliant red of his costume, which is clearly not contemporary, and the herm on the right establishes late antiquity as the period of the miracle; the dim broken buildings in the background recall Dürer. In the *Deësis with SS. Roch and Sebastian* (Plate 77) the saints, the Virgin and St. John intercede with Christ on behalf of the city in the middle distance with an intensity which is a vivid testimony to the ravages of the plague. The Virgin and St. John have been developed from those in the upper part of the *Martyrdom of St. Justina* (Plate 51) with an expressive *contrapposto* that is also found in the figure of St. Sebastian, whose pose is more dramatic than that of his immediate source, the St. Sebastian in *Doge Sebastiano Venier's Thanksgiving for the Battle of Lepanto* (Plate 57).

These qualities were not lost upon a younger generation of artists and Annibale Carracci's reform of painting in Bologna would not have been possible without the example of Veronese. One of the Carracci, probably Agostino, wrote in their copy of the 1568 edition of Vasari's

Lives: 'I have known Paulino and I have seen his beautiful works. He deserves to have a great volume written in praise of him, for his pictures prove that he is second to no other painter, and this fool passes over him in four lines, just because he wasn't a Florentine.' The praise is echoed in Annibale's paintings which set a pattern that was to be followed in the seventeenth century by giving the figures more bulk and weight, bringing them closer to the surface of the canvas and working out the landscape with a new sense of depth. The influence and the praise continued until the 1660s, when Bernini on his visit to Paris revived Vasari's prejudices against Venetian painting, and applied them to Veronese. This prejudice may well reflect the change in taste in Roman painting as Carlo Maratta and Giovanni Battista Gaulli grew away from an interest in Venetian painting but it was not shared by the French *Académie* where in 1667 Le Nôtre emphasized the nobility of the *Supper at Emmaus* (Plate 25) the quality of the drawing, the variety of the heads and their decorum.

It is precisely this awareness of the link between Veronese's virtuosity and the narrative that Reynolds destroyed in the *Discourse*, part of which was quoted on page 23. Reynolds' view was prejudiced by his dislike of Sebastiano Ricci who had rediscovered Veronese in 1708; Ricci, and following him Tiepolo, saw in Veronese bright colour, rich but unhistorical costume and grand patrician figures all of which they accomplished with a free, decorative brush-stroke. Interest in Veronese was strengthened, rather strangely, by the enthusiasm for the true expression of Christian sentiment at the beginning of the nineteenth century, which helped to shape Ruskin's admiration for the *Queen of Sheba before Solomon* (Plate 66), an admiration whose limitations have already been noted (page 5). Although the Pre-Raphaelites shared Ruskin's interest, Veronese's influence seems confined to some of their late work, while the interest, which Turner and Delacroix expressed in their writings on Veronese is not reflected in their paintings.

This fits with a wider change in the historian's view of Venice; Burckhardt's account of the Renaissance, published in 1860, with its emphasis upon the equality of the classes, the enjoyment of festivals, the development of the individual and the emancipation from religion,

became part of the romantic picture of the city that shaped Molmenti's account of Venetian private life, published in 1880. This account of Venetian society has been challenged by recent social historians who emphasize the intellectual life of the nobility, their important role in the Catholic reform movement, the skill with which the state adapted the *scuole* to accommodate the orders excluded from the highest offices and the city's continued commercial prosperity through to the beginning of the seventeenth century. This changed perspective should help us to accept that Veronese was, for all his limitations, an artist with a wider range and a more serious view of painting than is commonly acknowledged.

Notes to the Plates: In the dimensions height precedes width; all the pictures are oil on canvas unless otherwise stated.

The following abbreviations are used:

B.M.	*Burlington Magazine*	
A.B.	*Art Bulletin* J.W.C.I.	*Journal of the Warburg and Courtauld Institutes*
M.K.I.F.	*Mitteilungen des Kunsthistorischen Institutes in Florenz*	
M.D.	*Master Drawings*	
P.	*Pantheon*	

BIBLIOGRAPHICAL NOTE

The standard catalogue of the paintings is: T. Pignatti and F. Pedrocco, *Veronese*, Florence, 1991 (although deeply flawed) and of the drawings: R. Cocke, *Veronese's Drawings. A catalogue Raisonné*, London, 1984, (hereafter Cocke, 1984 followed by the catalogue number) P. Humfrey, *The Altarpiece in Renaissance Venice*, New Haven and London, 1993 offers a penetrating account of the background to Veronese's altarpieces. R. Cocke, *Paolo Veronese. Piety and Display in an Age of Religious Reform*, London, 2001 covers material not included here. 1988, the tercentenary of Veronese's death, was marked by a conference whose papers are collected in: *Nuovi Studi su Paolo Veronese*, ed. M. Gemin, Venice, 1990 (hereafter Gemin) and by two exhibitions, the major one: *The Art of Paolo Veronese, 1528-1588*, Exhibition Catalogue, intro. by T. Pignatti, ed. W.R. Rearick, National Gallery of Art, Washington, 1988 and the restoration of the *Marriage Feast at Cana*, J. Habert ed., *Les Noces de Cana de Véronèse. Une oeuvre et sa restauration,* Paris, 1992 (hereafter Habert)

Veronese's technique was studied in: N. Penny and M. Spring, 'Veronese's Paintings in the National Gallery. Technique and Materials: Part I', *National Gallery Technical Bulletin*, 16, 1995, 4-30 (hereafter Penny I)
N. Penny, A. Roy and M. Spring, 'Veronese's Paintings in the National Gallery. Technique and Materials: Part II', *National Gallery Technical Bulletin*, 17, 1996, 32-56.

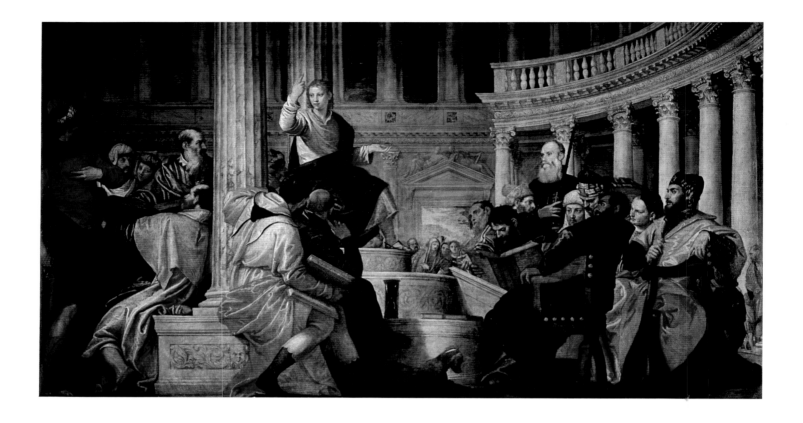

1 *Christ Preaching in the Temple*
MADRID, Museo del Prado. 236 x 430 cm.

The picture, which is dated: 'MDXLVIII' on the book
held by the man seated beneath Christ, was painted
when Veronese was only twenty years of age. The
scene is set in a striking evocation of the Temple of
Jerusalem with Christ raised on the steps as he
expounds the scripture; his parents enter in the
background in search of their son while the scribes
look surprised or burrow in their books, and behind
them stands the otherwise unidentified donor with a
red cross of Jerusalem embroidered on his black cloak.
The picture develops the tradition of Dürer's woodcut
of this subject, which was the model for the painting
by Bonifazio de' Pitati, the most distinguished

Veronese artist of the older generation. Bonifazio's
version was commissioned for the Council Chamber
of the Palazzo dei Camerlenghi in Venice in 1545,
where it must have been seen by the unidentified
patron on his pilgrimage to Jerusalem,
which would have started and ended in Venice. For all
the fluency of the composition it lacks the coherence
that Veronese was to achieve in his mature paintings.
The picture was first recorded in the Spanish Royal
collection in the Salon de los Espejos in the Alcázar in
Madrid in 1686, whence it subsequently passed to the
Prado. The date which was first noted by Michael
Levey, B.M., 1960, page 106 ff, is not accepted by
many Italian scholars but there seems little reason to
doubt it. See Cocke, 1984, p. 1 and 2.

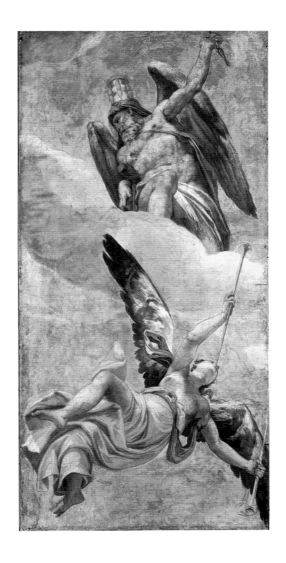

2 *Time and Fame*
CASTELFRANCO, Duomo. 353 x 168 cm.
Fresco transferred to canvas.

The *Time and Fame* is a fragment of the villa
decoration carried out for Benedetto Soranzo by
Veronese, together with Battista Zelotti and Anselmo
Canera in 1551, the date inscribed on another frag-
ment in the Seminary, Venice. The Soranzo, a Venetian
patrician family, had acquired a site for their villa in
Treville, Castelfranco in 1540. It was built towards the
end of the decade by Michele Sanmicheli, who
brought with him a team of young artists from his
native Verona. The *Time and Fame* was designed in
emulation of Agostino Chigi's Tiber loggia in the Villa
Farnesina in Rome, known to the architect, with
Fame's trumpet celebrating the elaborate -but now
lost- cartouche intended for the arms of Benedetto
Soranzo. This was designed with its supporting
victories by Veronese in a drawing now in Hamburg.
The exaggerated movement of Time (identified by the
hour-glass on his head) looked back to Giulio
Romano. Just before the villa's destruction in 1817 the
frescos were removed by Count Filippo Balbi. He sold
the bulk in London, but gave some fragments to
Castelfranco Cathedral. Some of the putti from the
loggia survive in the Museo Civico, Vicenza, at
Castelfranco and formerly in Paris and Bassano.
See, Cocke, 1984, p. 3.

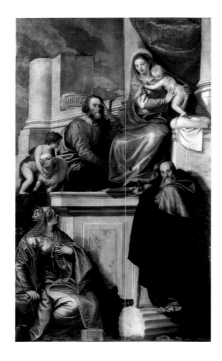

3 *Holy Family Enthroned with John the Baptist, SS. Anthony Abbot and Catherine*
VENICE, S. Francesco della Vigna. 313 x 190 cm.

Work on Sansovino's new church for the Observant Franciscans had begun shortly before 1536. That year Antonio and Lorenzo Giustinian acquired the fifth chapel on the north side of the nave. It was built and decorated from 1543 to 1551, the date of the inscriptions at either side of the altar. They were related to Doge Andrea Gritti, the key figure in the church's patronage, through their mother, one of Gritti's cousins. Their choice of artist, although probably influenced by relative costs, may also have been prompted by Veronese's unique command of a style indebted to Titian's Pesaro altar both in composition and handling (fig 2). The Virgin and Child, raised on a marble plinth with a cloth of honour suspended from twin columns, are joined by St Joseph, to whom the chapel was dedicated and the youthful Baptist, in an unequal struggle with a lamb determined to look out of the picture.
See P. Humfrey, 'La pala Giustinian a San Francesco della Vigna. Contesto e committenza', in Gemin, 299-308

4 *Temptation of St. Anthony*
CAEN, Musée des Beaux-Arts. 198 x 151 cm.

The agonized saint and the female temptress about to dig her fingers into his hand reflect the St. Jerome and the Virgin in Parmigianino's *Virgin and Child with SS. John the Baptist and Jerome* in the National Gallery London. The tempter derives from Caraglio's engraving after Rosso's *Hercules and Cacus* (see B.M., 1971, p.726 ff.); the ultimate source of the figure is Michelangelo's *modello (small wax model)* in Casa Buonarotti which also inspired Tintoretto's *Cain Slaying Abel* now in the Accademia, Venice of 1553. The picture was one of a series of canvases painted for the Cathedral, Mantua between 1552 and March 1553 at the commission of Ercole Gonzaga. The other Veronese artists who took part were Domenico del Moro, Paolo Farinato and Domenico Brusacorci; the scheme was completed by Fermo Ghisoni, Costa and G. M. Bedoli and the whole commission was probably the responsibility of G. B. Bertani. The picture, which has been cut down slightly, was removed on Napoleon's order in 1797, sent to Paris and thence to Caen in 1801. See Cocke, 1984, 25; G.A. Wojno Kiefer, 'Mid-sixteenth century Veronese painting in the Duomo of Mantua', *Antichità viva*, 26, 1987, p. 34-43.

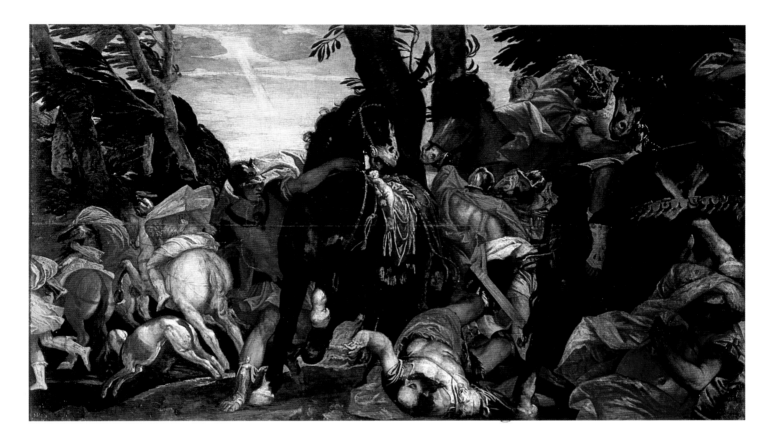

5 *Conversion of St. Paul*
ST PETERSBURG, Hermitage. 191 x 329 cm.

The *Conversion* had long afforded artists an excuse to display their mastery over rearing horses, a tradition that had been introduced to the Veneto by Jacopo Bellini in his sketchbooks and continued by Pordenone in a now lost painting which is known through a drawing (exhibited, Morgan Library, New York, 1965, no. 53). The combination of the rearing horse on the right, a motif with a distinguished history in the Renaissance, with the saint's horse raising its left leg to avoid trampling on St. Paul recalls the fresco on Niccolò Giolfino's house in Verona which had an old, but not necessarily reliable, attribution to Mantegna (see B.M. 1972, P.322 ff.). Although often dated to the end of Veronese's career the awkwardness of the composition and the close links with the *Triumph of Mordechai* (Plate 11) where the same motifs are used with greater feeling for the story, suggest an early date for this picture whose early history, before its acquisition by the Hermitage from Gatschina Palace in 1920, is not known.

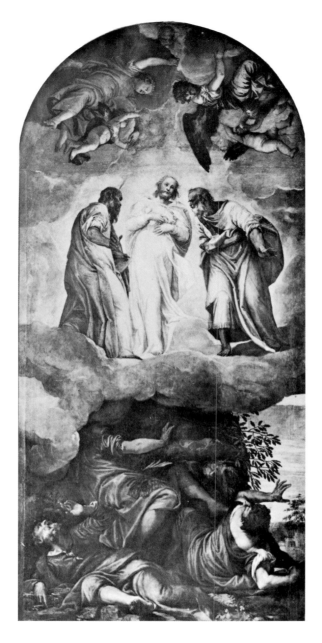

6 *Transfiguration of Christ*
MONTAGNANA, Duomo. 535 x 250 cm.

The composition with Christ, Moses and Elias on the mountain with the apostles below goes back to a Byzantine tradition which Giovanni Bellini had re-interpreted in his painting in the Museo Correr, Venice, which influenced Pordenone's 1511 version now in the Brera, Milan; the great cloud and the figure of Christ derive from Raphael's *Transfiguration* then in S. Pietro in Montorio, Rome. The frame, behind the main altar, which was built in imitation of that of Titian's *Assumption of the Virgin* in the Frari, Venice, was completed in 1554. The contract for the painting was signed in the villa of Francesco Pisani on the 3rd June 1555 and the picture was due for completion by Christmas 1556. Daniele Barbaro (Plate 22) was one of the canons at Montagnana and may have been responsible for giving the commission to Veronese.

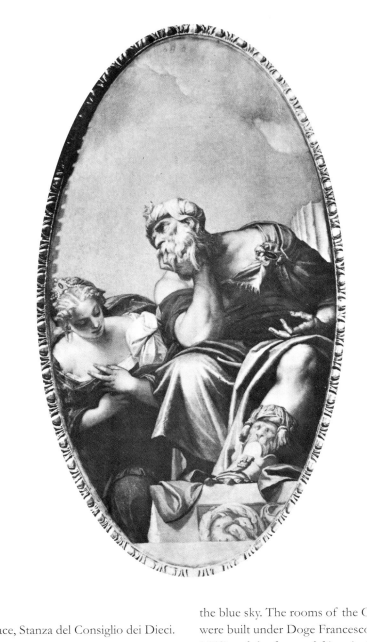

7 *Youth and Age*
VENICE, Ducal Palace, Stanza del Consiglio dei Dieci.
280 x 145 cm.

The meaning of the canvas is far from clear as the massive pensive (almost melancholic) man, freely inspired by Michelangelo, peers down at his companion who modestly covers herself. She is a reworking of the temptress in the *Temptation of St Anthony* (Plate 4) with a greater sense of plastic form and stronger lighting that is combined with rich colour in the bright red of the man's costume set off against the blue sky. The rooms of the Consiglio dei Dieci were built under Doge Francesco Donato (1545 to 1553) and the frescoed frieze includes the coat of arms of his successor, Marcantonio Trevisan who died in 1554. The canvases, which must have been begun by 1554, were still under way in 1556 when Sansovino (under the pseudonym Guisconi) referred to the work which was probably finished by 1560, the date of Sansovino's first guide-book to Venice where (for the first time) the decoration is referred to in the past tense.

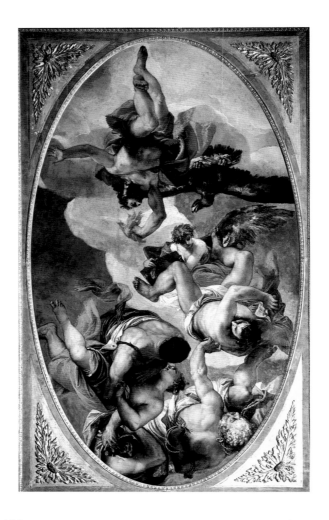

8 *Jove Expelling Crimes and Vices*
PARIS, Musée du Louvre. 561 x 330 cm.

The canvas originally formed the central oval in the Stanza del Consiglio dei Dieci of the Ducal Palace in Venice, from whence it was taken to Paris in 1797. It was removed to Versailles in 1810 and was later cut to fit the ceiling of Louis XIV's bedroom and was returned to the Louvre in 1858. *Jove Expelling Crimes and Vices* represented, according to Francesco Sansovino in 1581 'the causes which relate to the Council...so that you see with fresh invention Heresy; then there is Rebellion accompanied by Sodomy and by False love of Money.' The Council is embodied in both Jupiter with his eagle and thunderbolts and in the winged angel with bible, emblematic of Venice's defence of Catholic Faith. Heresy holding his book is the most prominent of the vices. By 1549 the Council had responded to the flood of Protestant literature by issuing their first catalogue of proscribed books. Rebellion breaks the ropes around his wrists while Love of Money clutches coins to his head. The final pair, though, illustrate Lust rather than Sodomy, which was obviously unsuitable as a subject. The programme for this suite of rooms was drawn up by Daniele Barbaro and the present canvas appears to relate to the functions of the Council which had been established after the Tiepolo–Querini plot in 1310 to guard the state against the threat of conspiracy and became responsible for the good of the patricians, and supervision of the police, clothes, prostitution etc. See: C. Hope, 'Veronese and the Venetian Tradition of Allegory', *Proceedings of the British Academy*, 71, 1985.

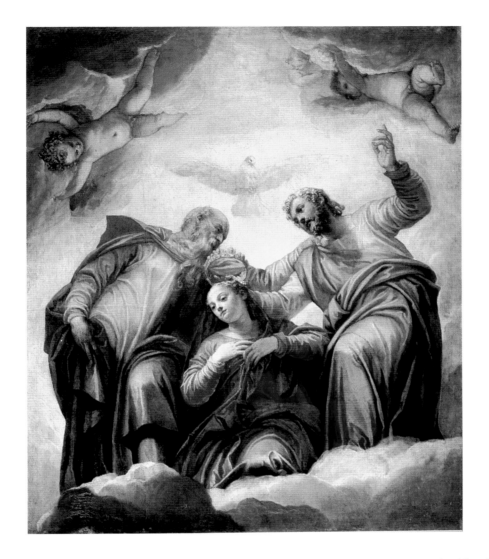

9 *Coronation of the Virgin*
VENICE, S. Sebastiano, Sacristy. 200 x 170 cm.

The Hieronymites, founded by Pietro dei Gambicorta in 1377, followed the rule of the observant Franciscans. The present church had been commissioned from Scarpagnino early in 1506, but was delayed by the League of Cambrai. The first dates for the new church are 1548, inscribed on the facade and 1553, the probable date of the frame of the sacristy ceiling. Fra Bernardo Torlioni, born in Verona in 1490, had been the order's Apostolic General Vicar in 1539, although he declined promotion three years later. The earlier canvases set above the plain panelling on the sacristy walls, combined Old and New Testament scenes. This may have been Torlioni's intention with the *Coronation of the Virgin*, but Veronese showed his concern for narrative clarity by confining the Old Testament scenes to the roundels set within subdued chiaroscuro scrolls, which are decorated with strapwork and swags, combining the new fashion for Fontainebleau with a taste for Mantegna. The Latin inscriptions give the date, 23 November 1555, 'Accept the crown on your head' and 'Accept the dignity and eternal crown.'
See: M. Kahr, 'The meaning of Veronese's paintings in the church of S. Sebastiano in Venice', J.W.C.I., 33, 1970, p. 235-247.

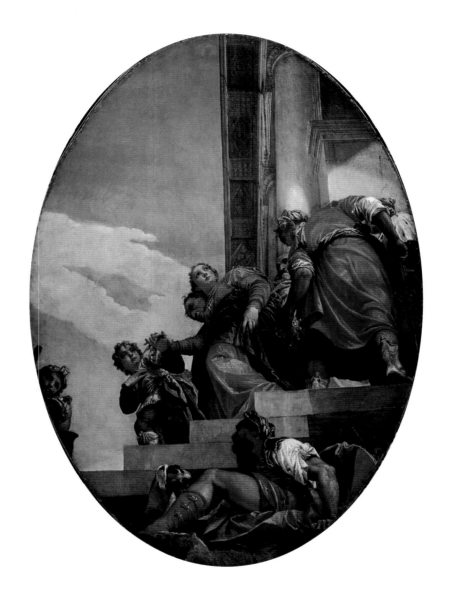

10 *Esther Brought before Ahasuerus*
VENICE, S. Sebastiano, Nave. 500 x 370 cm.

The title has been questioned by Kahr (see under plate 9.) who identified the scene as the: *Banishment of Vashti*. We have retained the traditional title partially because Ridolfi (writing in 1648) was generally reliable and because the action with the pathetic figure isolated by her red and green cloak against the yellow of the massive soldier who holds the crown and guards the king on the right of the canvas fits with the frightened Esther being brought to the harem for the first time. In feature she is identical with the Esther of the *Coronation of Esther* (Plate 10a). The decoration is completed by six balustrades with putti, four roundels with *Hope, Faith, Charity* and *Justice*, two balustrades with masks and eight angels flanking the two oval canvases.

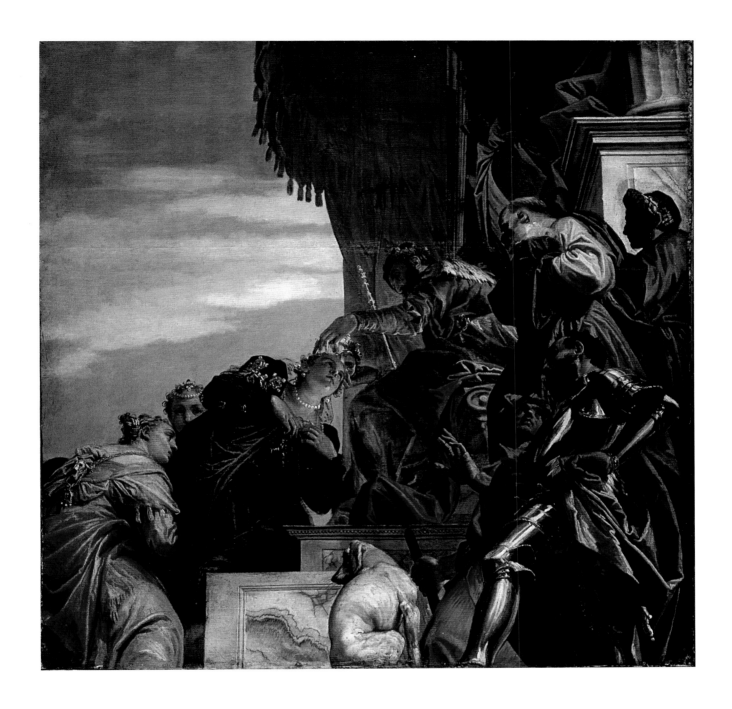

10a *Coronation of Esther*
VENICE, S. Sebastiano, Nave. 450 x 370 cm.

Veronese signed the contract for the ceiling paintings on 1 December 1555 and received the final payment on 30 October 1556. There are payments to two assistants but in contrast with the sacristy (Plate 9) all that we see appears to be autograph (although the assistants must have helped with the preparation of the canvases and the lay-in of the figures).

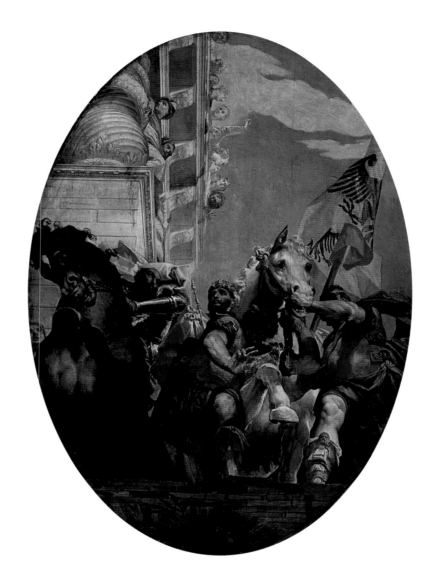

11 *Triumph of Mordechai*
VENICE, S. Sebastiano, Nave. 500 x 370 cm.

Why were scenes from the Book of Esther chosen for the decoration of the nave of S. Sebastiano? It had not engaged the attention of the early church fathers but the first commentary – that of Rabanus Maurus in the ninth century – established an interpretation of Esther as the church triumphant that is relevant to S. Sebastiano. The flag of the Holy Roman Empire waved so prominently in the *Triumph* must allude to the emperor's struggle with protestantism and is to be understood as indicating the triumph of the Catholic cause. It has been suggested that by analogy with the late medieval *Biblia Pauperum* Esther represents the Virgin; the central scene which influenced this doctrine was that of Esther's intercession with Ahasuerus to save the Jews, when she appeared before him unbidden, and he put out his sceptre to indicate that Esther was outside the law. The absence of this scene and of that gesture in the *Coronation of Esther* suggest that we must see it as an optimistic response to the crises that the Catholic Church had faced since the challenge of Luther in the early decades of the century. The drawings are discussed in Cocke, 1984, 6 and 6.

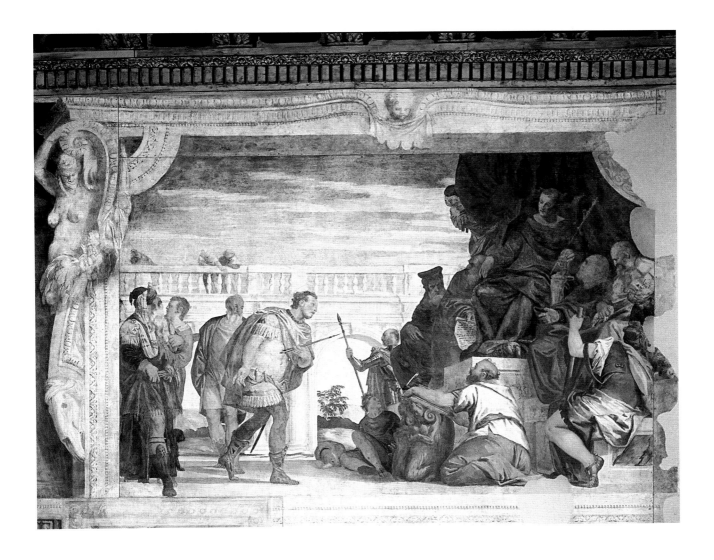

12 *Sebastian before Diocletian*

VENICE, S. Sebastiano, Fresco in the upper part of the Nave. Approx. 330 cm. in height.

The lighting of this fresco, which is taken from the window to the spectator's right, emphasizes the saint by placing the emperor and his retinue in shadow. Because of damage Veronese covered the fresco with a canvas (the date is uncertain) and it was uncovered in 1762. The canvas has survived only in fragments but its design was recorded in an engraving by N. Cochin. Veronese received 105 ducats for these frescoes on 31 March 1558 and a final 5 ducats on 8 September 1558; the bulk of the work may have been finished by March 1558, and because of the difficulty of working in the winter months, had possibly been carried out in 1557. The ornamentation of the frames reflects the influence of the school of Fontainebleau, the columns link with the work of the Rosa brothers (for whom see Schulz, B.M. 1961, 90 ff.) and the illusionistic doorway is a playful reworking of a device that Pellegrino Tibaldi had contributed to Perino del Vaga's frescoes in the Castel Sant' Angelo, Rome in the late 1540s.

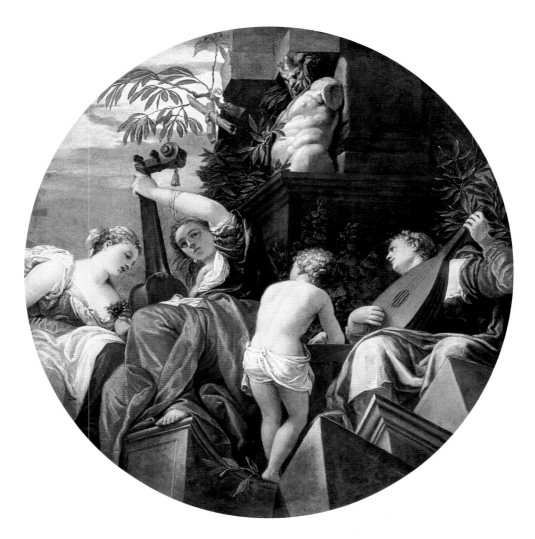

13 *Music: Arithmetic Music and Philosophy: Honour*
VENICE, Libreria Vecchia. Each 230 cm in diameter.

Veronese contributed these three tondi to the ceiling of
Sansovino's newly built library between August 1556
and February 1557; the other artists included Giovanni
del Mio, Battista Franco, Giulio Licinio, Giuseppe
Salviati, Andrea Schiavone, Battista Zelotti and Battista
Zelotti. Veronese was one of the few artists to make his
roundels understandable to a viewer not armed with the
programme. This is demonstrated in Vasari's description
of the central scene 'Arithmetic with certain all'antica
philosophers.' Arithmetic, foreshortened and with her
foot on a cornice, is deep in her book of calculation,
while musical harmony — identified by her open score
and flutes — kneels looking towards the double headed,
single, figure of wisdom looking back to mathematics
and forward to *Honour*. Harmony is the theme of the

left-hand tondo, admired by Vasari in an account which
played down both the phallic allusions of the Pan pipes
and the political significance of harmony for the myth
of the Venetian state. This latter theme was continued
in the final tondo, *Honour*, whose subject was shaped by
its position towards the Ducal Palace. Vasari noted that
sacrifices and crowns are offered to the seated figure of
Honour. The ruler oversees the good of his state — the
mother with her child- and its religion — the sacrifice in
the centre — and is offered a crown and the victor's
spoils. Veronese's ability to articulate meaning, and the
new, Venetian, richness of his handling were recognised
in the award by Sansovino and Titian, of a gold chain
for the tondo of *Music*.
See: C. Hope, 'Veronese and the Venetian Tradition of
Allegory', Proceedings of the British Academy,
p. 71, 1985.

14 *Arithmetic, Harmony and Philosophy*

14b *Honour*

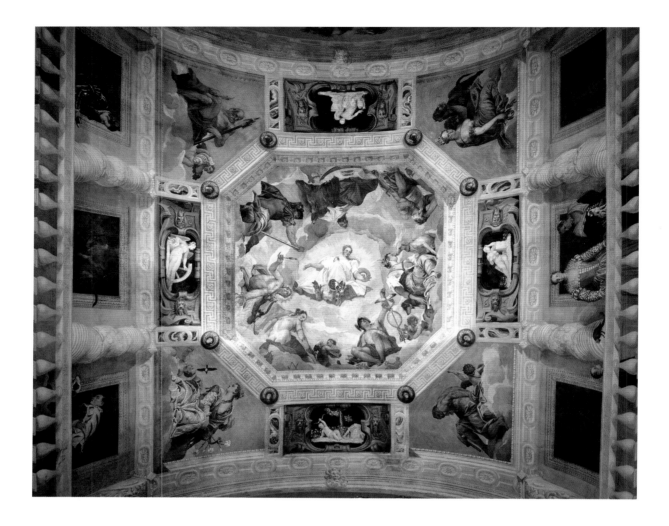

15 *Ceiling of the Sala dell'Olimpo*
MASER, Villa Barbaro (now Volpi) Fresco.

In the outer fields the four elements are symbolized by Vulcan for Fire, Cybele for Earth, Neptune for water and Juno for Air. In the centre the planets are linked with the zodiacal signs: Saturn with Aquarius and Capricornus, Jupiter with Sagittarius and Pisces, Mars with Aries and Scorpio, Apollo is close to Aries and linked with Leo, Venus with Taurus and Libra, Mercury with Virgo and Gemini and finally Luna with Cancer. The lady riding the huge headless snake has been identified as both Eternity and Truth but she is more likely to be the Muse Thalia who would link with the remaining figures and with those of the crossing (Plate 19) in a representation of the harmony of the spheres that fits with Daniele Barbaro's demand for an overall '*effetto*'. In the lunette, Venus reclines in the lap of her husband Vulcan in reference to Marcantonio's marriage in 1534; the feigned cameo above shows Cupid's triumph in reference to: '*Amor Vincit Omnia (love conquers all)*. The cameo opposite, above the lunette of Bacchus, shows Abundance with a cornucopia and a jug of wine. The two remaining cameos show Fertile Nature and Fortune balancing the good with the bad.

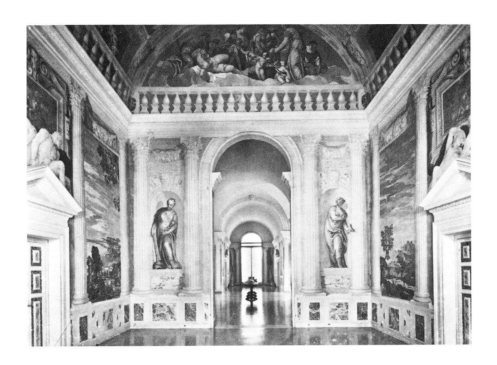

16 *Walls of the Sala dell'Olimpo*
MASER, Villa Barbaro (now Volpi), Fresco.

16a *Ceiling, Stanza del Cane* (overleaf)
MASER, Villa Barbaro (now Volpi), Fresco.

The elegant Corinthian columns frame the figures of Peace (on the left) and Faith (on the right); the grisaille frescoes above the two doors at the side embody the best principles of Antiquity and Christianity in *Marcus Curtius* and the *Good Samaritan*. Above the balustrade on the left two boys are shown holding a dog and a book while on the right a nurse, a mother and a young child look in. This view shows the room as it appears to the spectator who has just left the nymphaeum and looks towards the crossing (Plate 19). A letter written to Daniele Barbaro in 1559 refers to the nymphaeum, which shows that Vittoria must have worked at the villa by 1559, and it seems possible that this provides the date for Veronese's work in the villa (see for this and the detailed account of the decoration, J.W.C.I. 1972, p.226 ff.).

Discord, identified by her knife, sits to the left threatening the back of the standing lady who is squabbling with the lady seated on the globe for the cornucopia. The lion at the feet of the central figure identifies her as Munificence while the globe and the cornocopia are the attributes of Providence. The general message of this room (to the west of the Sala dell'Olimpo), which is echoed in the room on the other side where it is put in Christian terms, is: Charity must be tempered by Foresight lest it give rise to Discord. This fits with the Aristotelian temper of Daniele Barbaro's introduction to his edition of Vitruvius, where he expressed the view that: 'Prudence is the mode which makes the intellect regulate the will in those things which contribute to one's own good, it is that which makes us just, modest etc.' The fresco beneath is probably a warning not to be lulled by fickle fortune, while on the other side Saturn and History draw our attention to the Holy Family on the short wall.

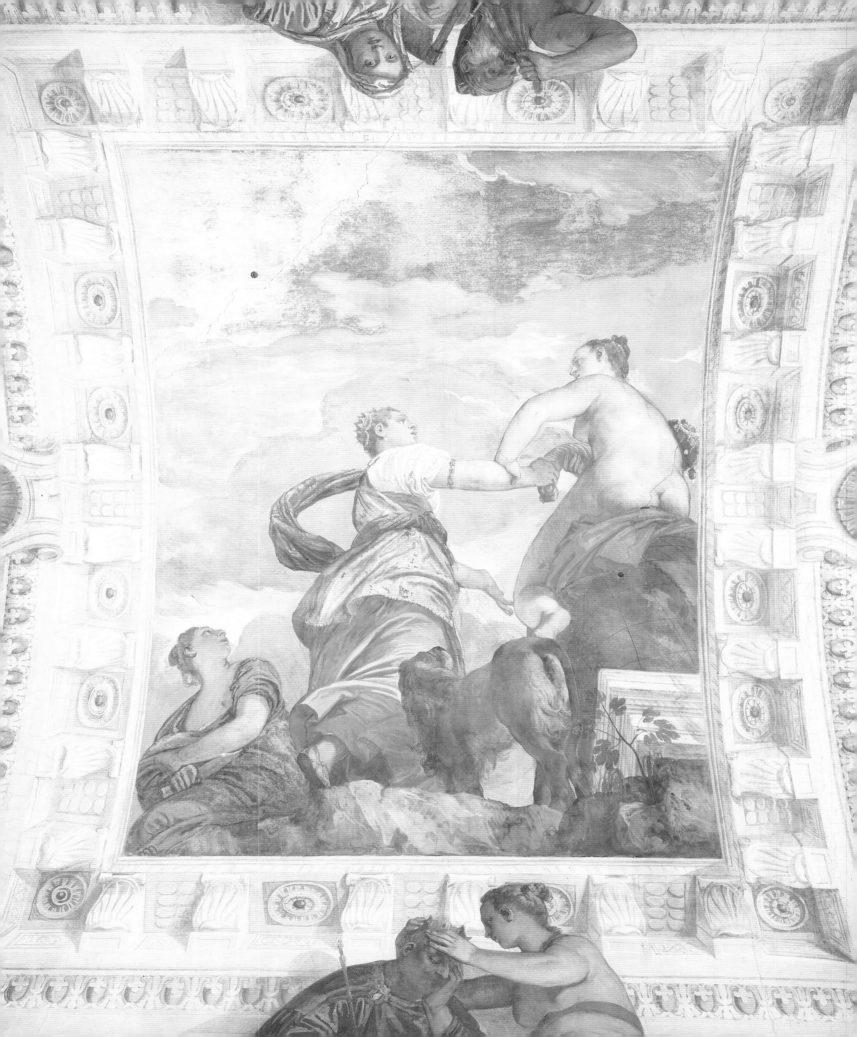

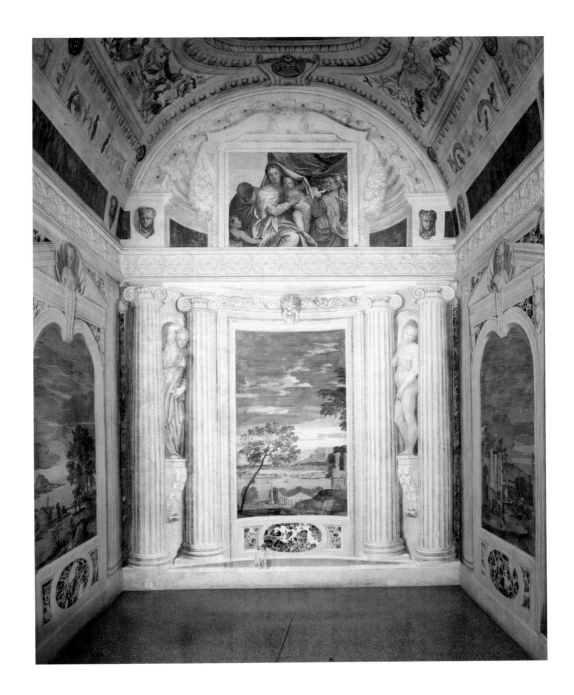

17 *Walls of the Stanza della Lucerna* (above)
MASER, Villa Barbaro (Now Volpi), Fresco.

Here the walls are dominated by the appearance of the
Holy Family (above the two columns) in a (painted)
frame above the cornice. This is taken up in the ceiling
fresco with its emphasis upon the primacy of the
Catholic Faith which had a special relevance for
Daniele Barbaro who as patriarch Elect of Aquileia
had played an important part in refuting the charges of
heresy faced by the patriarch, Giovanni Grimani, at the
Council of Trent in 1562. The Ionic columns
differentiate this room and the Stanza del Cane from
the Sala dell'Olympo and the Crossing, which are
linked thematically. The brilliant evocation of a
classical sea-port was achieved with the inspiration of
literary rather than visual models.

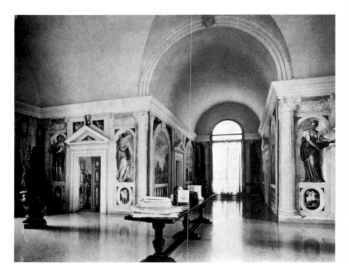

19 *Walls of the Crossing*
MASER, Villa Barbaro (Now Volpi), Fresco.

20 *Ceiling of the Stanza di Bacco*
MASER, Villa Barbaro (Now Volpi), Fresco.

This view continues that of the walls of the Sala dell'Olimpo looking to the window on the main south facade. We see three of the eight musical ladies who inhabit the niches of the crossing while the remainder of the walls are frescoed with landscapes set behind balustrades. The boy entering through the fictive door balances a real door opposite and the illusion, which was first used in the church of S. Sebastiano, was used again on the balancing wall to the right and again in one of the rooms after the Stanza della Lucerna, where a hunter is shown entering the villa. The eight ladies in the crossing were identified as Muses by early sources and this can be sustained if we assume that the ninth (Thalia) is in the centre of the ceiling of the Sala dell'Olimpo (Plate 17); the view that the programme illustrated the harmony of the spheres would explain the emphasis upon musical instruments in this fresco. The walls suffered terribly at the hands of the Austrians in the nineteenth century who slashed many of the landscapes; there was formerly a trellis on the ceiling of this room.

The central opening is completed by a trellis. Bacchus pressing grapes into the cup held up by the huntsman appears as a god of fertility both here and in one of the lunettes in the Sala dell'Olimpo where he is accompanied by Abundance and Ceres, who in this room is seated above the fireplace with Pluto. The Barbaros had owned a farm at Maser at least since 1514 and it had been enlarged before the commission to Palladio to rebuild the villa and its farm buildings sometime in the 1550s. The invocation of Bacchus as a god of fertility is a suitable choice of subject for a villa that was used as a farm, but here it is linked with his other role, as leader of the Muses, whose music is heard on the right of the fresco. In the companion room at the front of the house Venus is linked with Mars, in celebration of marriage.

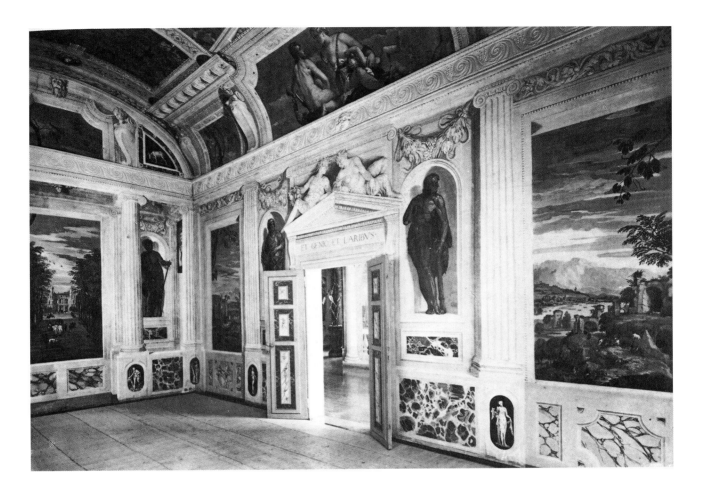

21 *Walls of the Stanza di Bacco*
MASER, Villa Barbaro (Now Volpi), Fresco.

Apollo with his lyre and Venus about to give suck to Cupid echo the dual role of Bacchus as god of fertility and of music in the centre of the ceiling. Both the depth of the illusionistic walls and the brilliance of the colour reveal the invention with which Veronese transforms traditional schemes. The fireplace (opposite the doorway) established a rhythm for the Ionic pilasters of the walls which is taken up by the squat caryatids above the cornice, which echo those designed by Sebastiano Serlio. The vine spreads over the trellis and down over part of the landscapes; this illustration of the *locus amoenus*, which derives from the upper logge in the Vatican decorated by the Raphael workshop, is inspired by part of Pliny the younger's description of his Tuscan villa: 'Another room is situated close to the nearest plane tree, its sides are covered with marble up to the cornice; on a frieze above the foliage is painted with birds perched among the branches; in this room is placed a little fountain.'

21 *Detail of Ceiling of the Stanza di Bacco showing Apollo and Venus*
MASER, Villa Barbaro (Now Volpi), Fresco.

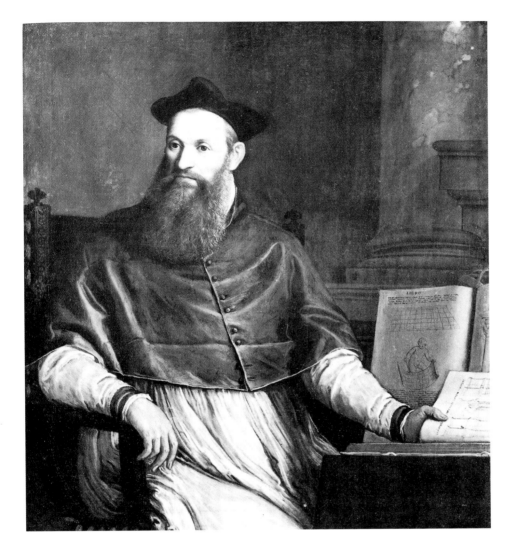

22a *Detail of illustration from 1556 edition of Vitruvius*

22 *Portrait of Daniele Barbaro*
AMSTERDAM, Rijksmuseum. 118 x 104 cm.

The picture was first recorded in the Hensler collection, Basle, in 1926 from whom it was acquired by Otto Lanz, Amsterdam by 1929 whence it passed to the museum in 1952. The sitter's identity is established by the 1556 edition of Vitruvius at which he is looking. The comparative illustration of page 235, Plate 22a, shows how Veronese has reworked the illustration which he has combined with a temple facade taken from Book Three; this illustration does not recur in Book Nine of the 1567 edition where the frontispiece has also been changed. These changes, together with the contact between Veronese and Barbaro in the mid 1550s (see Plates 8 and 16) suggest a date of around 1556 for the portrait. He appears as a younger man, not in ecclesiastical garb (he became Patriarch elect of Aquileia in 1550) in the 1545 portrait by Titian which is now in National Gallery of Canada. A smaller portrait of a Patriarch of Aquileia (presumably but not necessarily Barbaro) was no. 65 in the 1682 inventory of Veronese's heirs with dimensions of about 51 x 42 cm. It might be the version in the Foscarini collection, which was engraved by Cattini (d. 1800). It is clear from other examples that Veronese made small portraits from life, which he then re-used in larger portraits. Another version, now lost, of the Amsterdam portrait was sold from Consul Smith's collection in 1762.

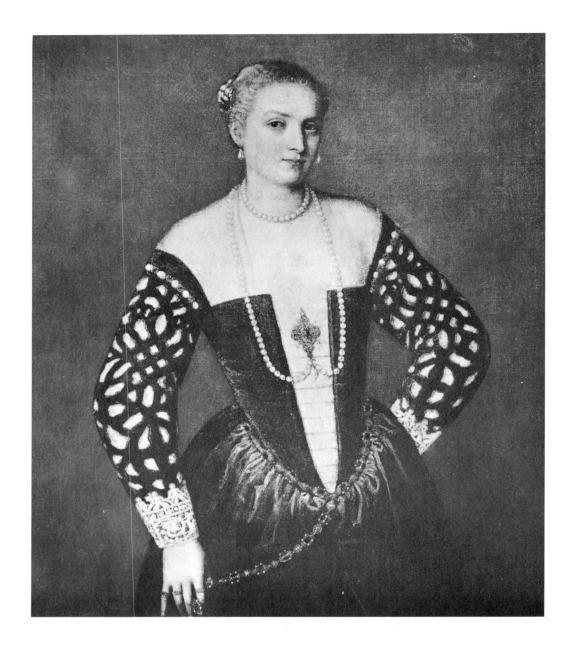

23 *Portrait of a Woman*
DOUAI, Musée de La Chartreuse. 106 x 87 cm.

This splendid portrait was bought from the collection of the Duc de Lynes by Mme. Wagner who sold it to the Museum in 1871. The directness with which the sitter is presented is matched by the *Belle Nani* in the Louvre. In other, probably later female portraits, Veronese introduced a curtain behind the sitter. These include the *Portrait of a Lady as St Agnes* in the Sarah Campbell Blaffer Foundation, Houston, the *Portrait of a Lady with a small dog* in the Thyssen collection, Madrid and the *Portait of a Lady* in the Altes Pinakotek, Munich.

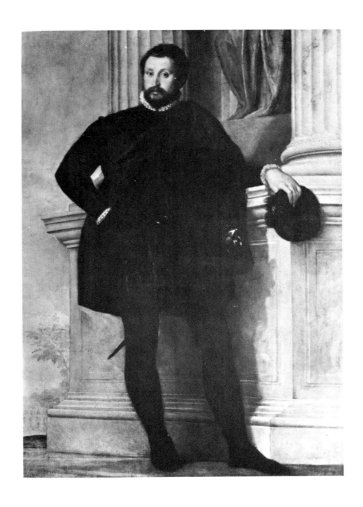

24 *Portrait of a Man*
LOS ANGELES, Getty Museum. 193 x 135 cm.

This picture which was acquired for its present collection from Wildenstein in 1955, is not recorded in any sources before its sale by the Countess Salvi Pindemonte-Moscardo to Richard Pryor in 1802. At that time it was engraved as a self-portrait, but comparison with the self-portrait in the *Marriage Feast at Cana* (Plate 33a) shows that this late tradition is unreliable; the view of St. Mark's in the background suggests that the sitter may be a procurator. The ease with which the figure stands in front of the Architecture develops from the 1551 *Francheschini portrait* in Sarasota and the *Portrait of Giuseppe da Porto with his son Adriano* in the Contini-Bonacossi Bequest, Florence, which is usually dated to around 1552 on the evidence of the age of the children who accompany da Porto and his wife in the rubbed companion painting in Baltimore. The figure is related to the colonnade with greater assurance in the three-quarter length *Portrait of Alessandro Contarini* in Dresden which must date to the early 1570s. He reappears (to all appearances unchanged) as an admiral in a portrait in Philadelphia in whose background we see a galley which may be the St. Christopher of which he was in charge in 1570; although wounded, he fought in the Battle of Lepanto in 1571, the approximate date of the Dresden and Philadelphia portraits.

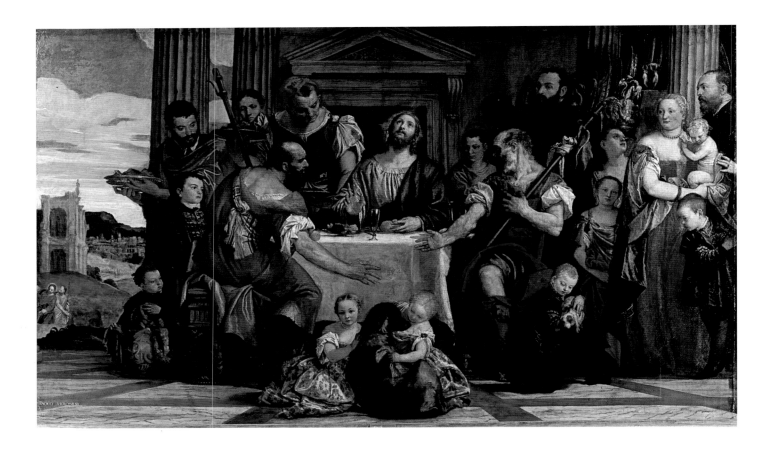

25 *Supper at Emmaus*
PARIS, Musée du Louvre. 290 x 440 cm.

In the distance we see Christ walking with the two
apostles who recognize him as he blesses the bread;
the central group was much admired at Le Nôtre's
1667 *conférence* on the painting where it was rightly
argued that the breach of decorum caused by the
unidentified donors' enthusiasm to witness the scene
was not the responsibility of the artist. We can,
however, see the skill with which later Veronese was to
cope with a comparable problem in the 1571 *Virgin and
Child with SS John the Baptist, Jerome and the Coccina Family*

(Plate 46) where the marble columns divided the
earthly sphere from the heavenly. Both because of this
and because of the colour the picture has always been
dated to the 1550s. It was first recorded in the 1635
inventory of the collection of Charles Emanuel II of
Savoy with a note that it had been given to the Duke of
Créqui who was then campaigning for Charles
Emanuel in Savoy. Subsequently it was in the collection
of Cardinal Richelieu and, although not included in the
list of paintings ceded to the King in 1665, was in the
Royal Collection by 1667, the date of Le Nôtre's
conférence.

26 *Two Philosophers*
VENICE, Libreria Vecchia. Each 250 x 160 cm.

The figures, who develop the style of the apostles included in the fresco decoration of the monks' choir at S. Sebastiano, formed part of a series of twelve painted for the Library in 1560. They have often been moved and were clearly not designed for their present position flanking the entrance door of the main reading room. There were once four philosophers in the vestibule leading to the reading room who were removed in the 1590s when the Grimani collection was placed there. In July 1560 (some months after the payment to Veronese) the vestibule was granted to Federico Badoer's Academy where the Venetian nobility were, for a time at least, taught Greek. The two philosophers by Veronese may well have formed part of this scheme, the one with the book encouraging the young nobles in their study while his companion looked up at Titian's *Allegory of Wisdom* in the ceiling, the source of their learning.

27 *SS. Geminianus and Severus* (left)
MODENA, Galleria Estense. 441 x 240 cm.

The saints formed the outside of the organ shutters
from the now destroyed church of S. Geminiano,
Venice; on the inside were SS. John the Baptist and
Mennas. The saints with their brilliant costumes look
towards the main altar of the church and are set in
front of a niche that recalls that of Bellini's S. *Zaccaria
altar* with a festoon in the upper part that derives from
the work of Giovanni da Udine in Rome. The
unification of the organ shutters when closed follows
a Venetian tradition that had begun with Giovanni

Bellini and continued with Sebastiano del Piombo. In
1558 Benedetto Manzoni had undertaken to pay for
the new organ which is referred to as finished by
Sansovino in 1561, who also explicitly mentions the
paintings. The engraving from Plate 52 of Coronelli's,
Singolarità di Venezia (ca. 1709) (Plate 27a) shows the
old, round-headed, organ that was replaced by a square
one in the early years of the eighteenth century (it is
shown on Plate 50 of Coronelli); the present canvases
have been adjusted to fit with the new organ while the
other two saints were cut down. They were removed at
the time of the destruction of the church in 1807 and
were reunited in Modena in 1924.

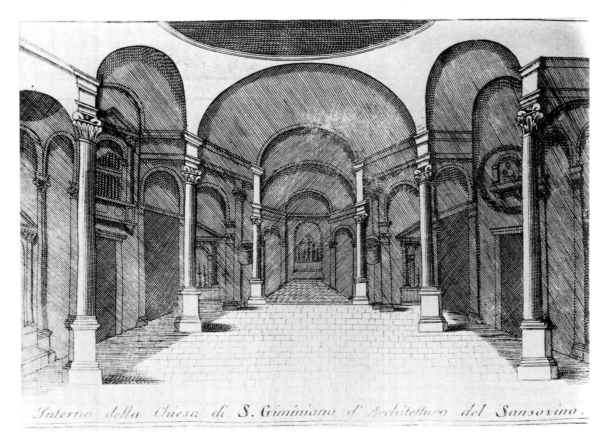

Interno della Chiesa di S. Geminiano d'Architettura del Sansovino.

27a *View of the interior of Ss. Geminiano, Venice,*
from V. Coronelli
Singolarità di Venezia; Venice (c. 1709)

28 *Presentation of Christ*
VENICE, S. Sebastiano, Organ. 490 x 185 cm.

The organ, which covers some of the frescoes in the upper nave of the church, was built by Domenico Marangone to the design of Veronese beginning in October 1558 and Veronese received the final payment for his canvases in April 1560. Few earlier Italian organs have survived, but a comparison with those and with earlier Venetian altars suggests that Veronese's simple and effective design with the arch breaking through the pediment was an innovation, which may derive from the illustration of an antique doorway outside Rome by Sebastiano Serlio. The *Presentation of Christ* reworks the version in Dresden with greater clarity and the fussy detail of the Dresden canvas has gone. The altar for instance, is covered by a drape, both the page holding the bowl in the foreground and the lady with the basket of doves (a traditional element in the ceremony of the Purification, as are the candles held by St. Joseph) look at the central group.

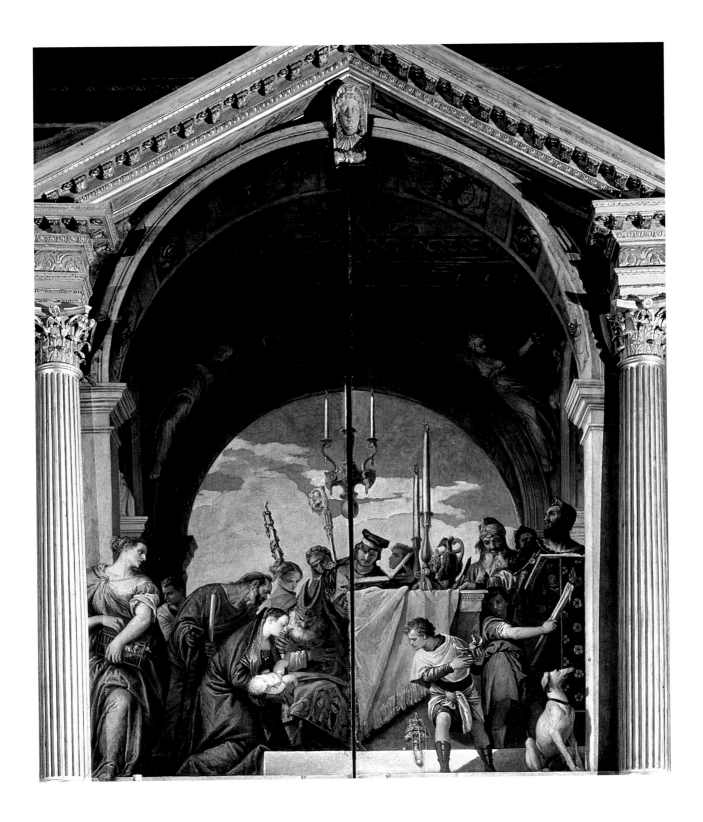

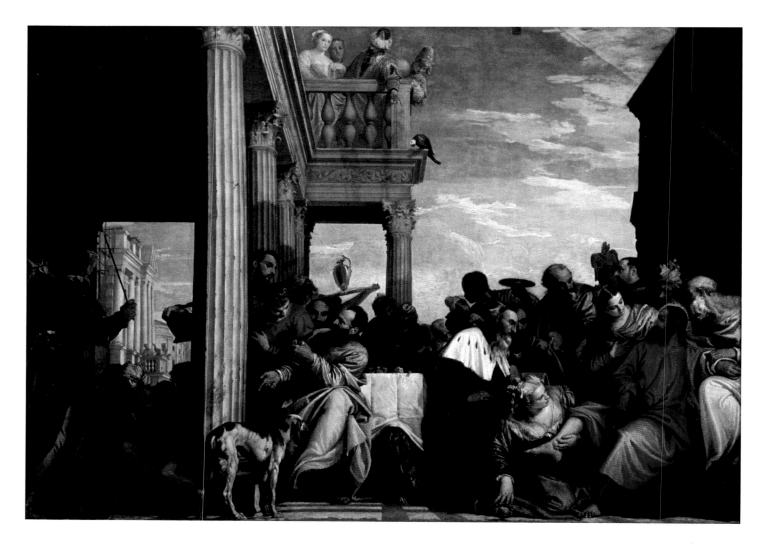

29 *Feast in the House of Simon*
TURIN, Galleria Sabauda. 315 x 451 cm.

The Feast was commissioned for the refectory of SS. Nazaro e Celso, Verona, a Benedictine monastery in the congregation centred on San Benedetto Po. Although Abbot Mauro made the first payment of ten crowns on 3 January 1556, the resemblance with the organ shutters in San Sebastiano suggests that it be dated 1560 (Plate 28) The red of Christ's robe, which is the brightest tone in the canvas, offsets the shadow in which he is placed, and is the focal point of the colour, while the Magdalen at his feet is bathed in light as she gazes at him. The *Feast in the House of Simon* had traditionally formed a part of cycles of Mary Magdalen and only in the sixteenth century did it become an isolated subject painted in a refectory. Moretto's version of 1544 painted for SS. Fermo e Rustico, Monselice, stayed close to Marcantonio's engraving of this subject, adding a few servants at the sides. Veronese, who filled his canvas with more detail, looked back to Carpaccio and possibly to Mantegna for the low view-point and the opening in the relief-like grouping in the centre, which recalls the frescoes in the Eremitani, Padua. The picture was acquired by the Spinola, family, Genoa in 1650 from whom it passed to Carlo Alberto in 1825 and thence to the gallery in 1832.

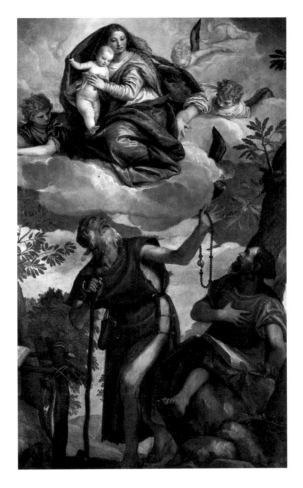

30 *Virgin and Child Appearing to SS. Anthony and Paul*
NORFOLK, Va. Walter P. Chrysler Museum,
285 x 170 cm.

Veronese's three altars for the Benedictine monastery
of San Benedetto Po, a part of the congregation of
Santa Giustina, were ordered on 27 December
1561 and were completed by 30 March 1562. The
speed of execution is reflected in their loose handling.
The Consecration of St Nicholas, intended to be hung
with St Nicholas's head above that of the spectator,
formed the second altar on the right and the *Virgin
and Child Appearing to SS. Anthony and Paul*, the second.
Andrea da Asolo, responsible for the commission,
succeeded Girolamo Scrocchetto at San Giorgio
Maggiore in 1564, just in time to be included among
the portraits on the right of the *Marriage Feast at Cana*,
(p78). Veronese's *St Jerome* from the first chapel on the
right was, like the *Consecration of St Nicholas*, sold to
England, but destroyed by fire in 1836; the copy in the
church shows that, like the two surviving canvases, it
emphasized the appearance of the Virgin to the saint
in the desert. The earlier fresco of St. Anthony Abbot
in the lunette above the second chapel, which shows
him eating in the rocky desert, contrasts with the
emphasis upon the heavenly intervention in Veronese's
canvases; there is no need for an angel to carry down
St. Nicholas's mitre and staff and the appearance of
the Virgin to both St. Anthony and St. Jerome is
unusual. The pictures all remained *in situ* until at least
1763; the copies that replaced them were probably
made in the 1790s when the originals were displayed
in a gallery in the monastery. The Napoleonic suppres-
sion of parish churches led to their removal; the
Consecration of St Nicholas was sold in London in June
1814 when it was bought by the British Institution by
which it was presented to the Gallery in 1826. The
Virgin and Child Appearing to SS. Anthony and Paul
moved to Mantua and then to a private collection in
France from where it passed to the present collection
in 1962.

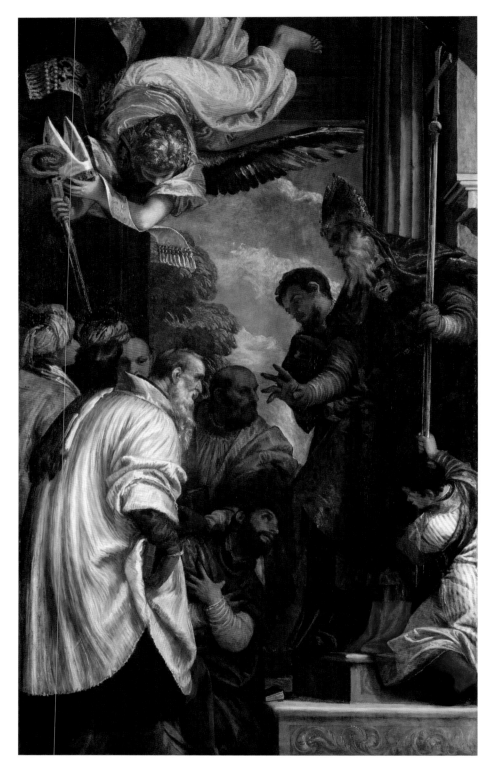

30a *Consecration of St. Nicholas*
LONDON, National Gallery. 282 x 170 cm.

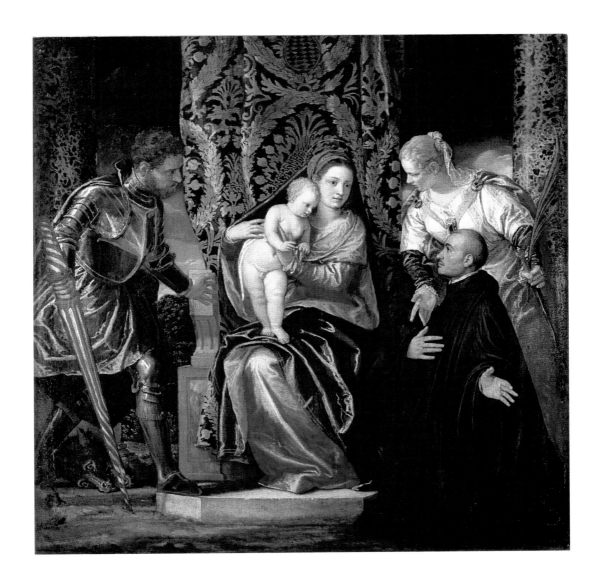

31 *Virgin and Child with Sts George, Justina and a Donor, Benedetto Guidi (?),*
PARIS, Musée du Louvre 90 by 90 cm

Included in the 1662 catalogue of the collection of Louis-Henri de Loménie, Comte de Brienne. It was acquired by Everard Jabach, who in turn sold it to Louis XIV in 1671. The de Brienne catalogue suggested that the saints connected this private devotional canvas with San Giorgio Maggiore. The donor re-appeared some ten to twelve years older among the witnesses on the right of the *Marriage Feast at Cana* (Plate 78). He may be Benedetto Guidi, who entered the order on 21 March 1551 and died aged 58 in 1590. Guidi dedicated a poem to the *Marriage Feast at Cana* in 1565: 'the skilful hand which created shadows and colours. All the sculptors come and the painters to admire it three, four and six times......The columns and arches rise to the sky in a Great View (Gran Prospettiva): and PAOLO is praised with eternal fame.'

See: T. Cooper, 'Un modo per La riforma cattolica? La scelta di Paolo Veronese per il refettorio di San Giorgio Maggiore', in V .Branca & C. Ossola eds., *Crisi e Rinnovamenti del rinascimento a Venezia, Florence*, 1991, 271-292.

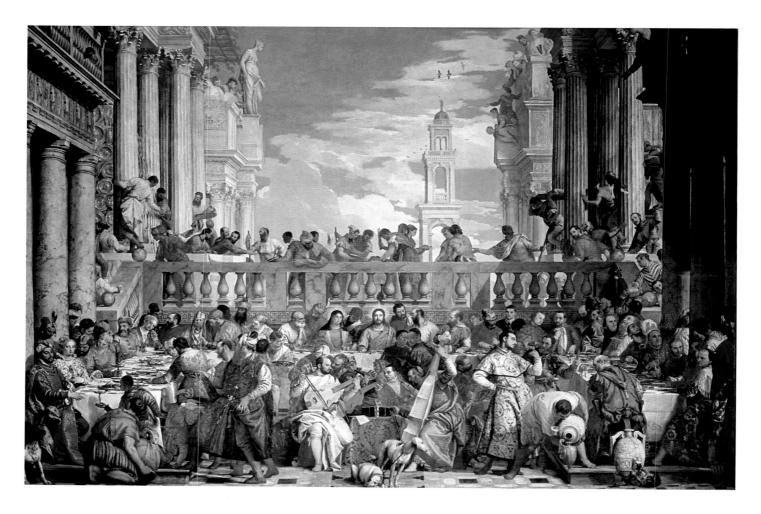

32 *Marriage Feast at Cana*
PARIS, Musée du Louvre. 660 x 990 cm.

This enormous canvas was painted for the refectory of
S. Giorgio Maggiore, Venice, from June 1562 until
September 1563; it was removed to Paris in 1797 and
placed in the Louvre in 1801. Writing in 1611 Thomas
Coryate noted that the monastery was: 'a passing
sumptuous place, and the fairest and richest monastery
without comparison in all Venice, having at least three-
score crowns for a yearly revenue.' This, as modern
scholars have observed, played its part in the *Marriage
Feast at Cana* but as was emphasized in the text, it is
counteracted by the servants' awareness of the miracle.
This reading finds confirmation in the version of this
subject that Veronese painted for the Coccina family in
ca. 1571, now in Dresden.

The restoration, from 1989-1992, involved the largest
X-ray ever undertaken in the Louvre. It revealed
detailed changes within a well-established architectural
and compositional framework: the outline of governor
of the feast – in green – was enlarged, his head was
separated from the servant behind; among the
musicians Veronese bent forward behind his viol; the
right arm of the servant contemplating wine was
closer to Titian's back, the angle of the step on which
the table rests was moved back. Andrea da Asolo was
added to the portraits on the right, which included a
posthumous one of Pietro Aretino.
See: Habert, 1992

Details of *Marriage Feast at Cana* (right and overleaf)

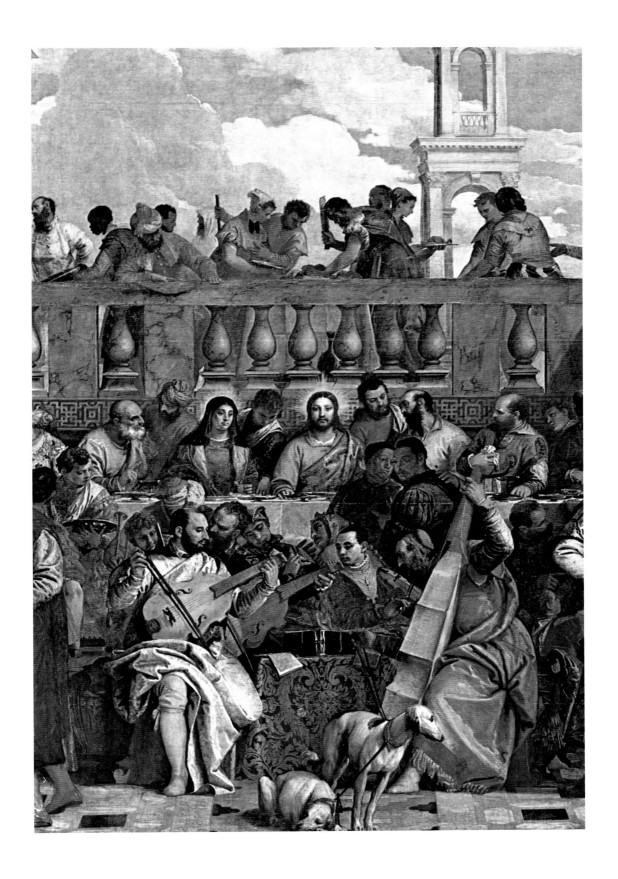

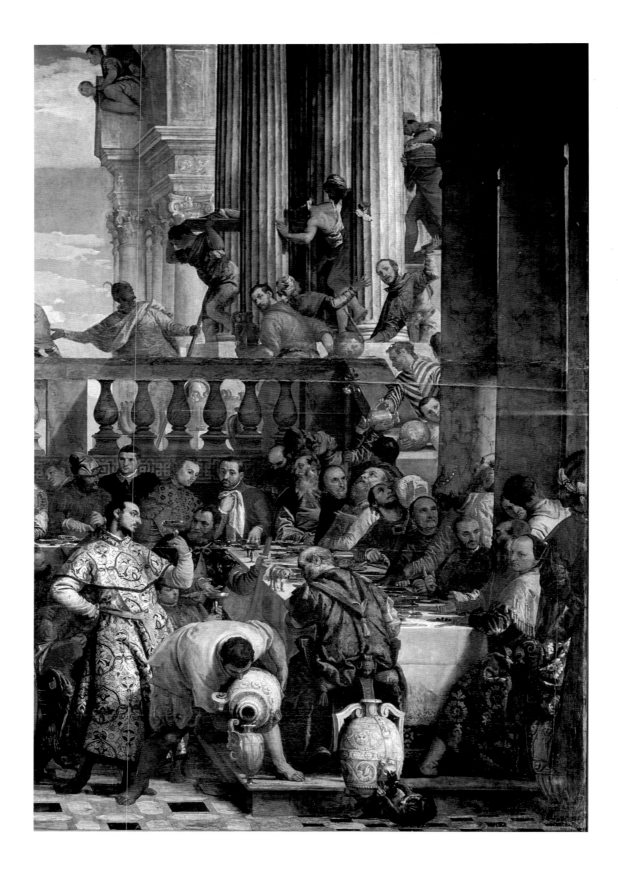

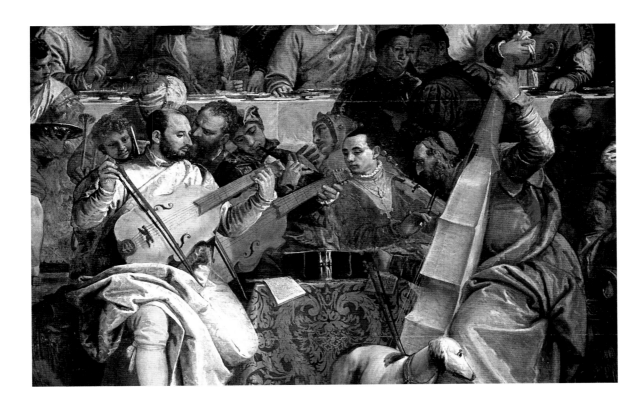

33 *A Group of Musicians, Detail from the Feast*
PARIS, Musée du Louvre.

Veronese plays a tenor violin in the left foreground
and Titian the double-bass on the right; the other
instruments are (from the left) a trombone, another
viol, a cornetto muto (it looks like a flute) and a violin.
The music was suitable for a secular occasion and the
hourglass poised in the centre of the table refers to
Christ's response to his mother that: 'mine hour is not
yet come'; that the musicians are Venetian painters
underlines the analogy between the harmony of music
and that of colour to which Vasari had alluded in the
Treatise on Painting which preceded the 1550 edition of
his *Lives*. That the heads included portraits was first
noted by Boschini in 1674 and comparison with
Agostino Carracci's, admittedly much later, engraving
of Veronese (frontispiece) confirms that identification:
Titian resembles his late self-portraits in Berlin and
Madrid, but it is not possible to check that Jacopo

Bassano plays the cornetto muto. Boschini is wrong in
identifying the violinist as Tintoretto who is more
likely to be shown playing the second viol next to
Veronese; the bearded and foreshortened head fits
with the self-portraits of Tintoretto in the Victoria and
Albert Museum and the Louvre. The head of the man
behind this group in a jester's hat with bells on looks
like a slightly older version of the man on the right of
the *Allegory of the Arts* now in the Capitoline Museum,
Rome, whose plan identifies him as an architect. Since
1560 Palladio had been in charge of the rebuilding of
the refectory at S. Giorgio Maggiore, Venice, if this
figure is a portrait of Palladio it would express both
Veronese's conviction about the relative merit of
painting and architecture, and, no doubt, explain why
Palladio should comment on many, to our eyes, dull
decorative schemes in his villas but ignore those at
Maser. No certain early portraits of Palladio survive, in
spite of the identification proposed by C-A Isermeyer,
Festschrift Herbert Siebenhüner, 1978, pp 137–142.

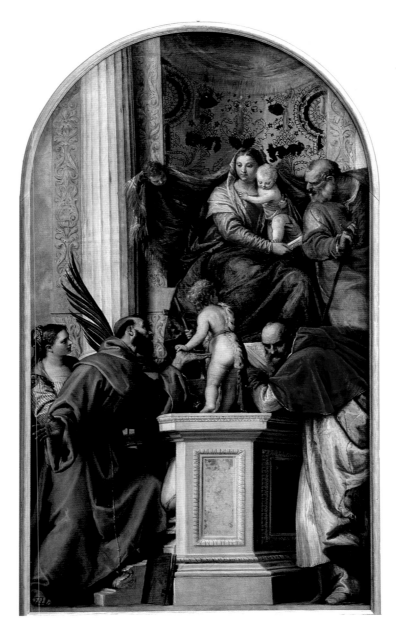

34 *Holy Family with SS. John the Baptist, Francis, Jerome and Justina*
VENICE, Gallerie dell'Accademia. 333 x 191 cm.

The altar was painted for the sacristy of S. Zaccaria at the commission of Francesco Bonaldi who in 1562 was given permission to rebuild it in memory of his father, Jerome, and of one of his sons John, both of whom had died the previous year. It was removed to Paris at the orders of Napoleon in 1797 and returned to the Accademia in 1815. The energy with which the saints communicate with the Holy Family is found in the much dirtier *Marogna altar* in S. Paolo, Verona of 1565. Three small devotional canvases link with these two paintings: the *Virgin and Child with Michele Spavento and an Unidentified Saint* in S. Sebastiano, Venice, the *Holy Family with St. John the Baptist* in S. Barnaba, Venice, and the *Virgin and Child with St. Peter and an Unidentified Saint* in the Museo Civico, Vicenza.

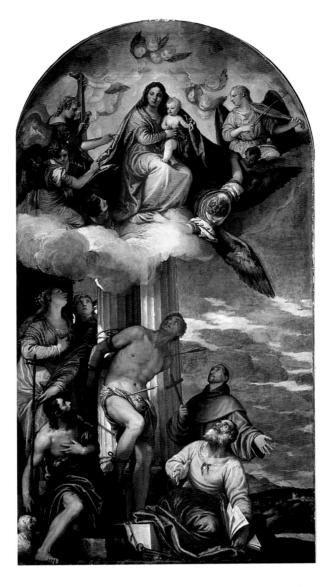

35 *Virgin and Child appear to SS. Sebastian, John the Baptist, Peter, Catherine and Elizabeth (?)*
VENICE, S. Sebastiano. 420 x 230 cm.

The patronage of the chancel, acquired by Pietro Mocenigo and his wife Cataruzza Cornaro in 1532, passed to their heirs, the Soranzo. In 1559 Lisa, the widow of Zuan Soranzo and the family's executrice, commissioned Veronese to design the chancel, which was built by Salvador Tagiapietra between 1559 and 1561. Pignatti has suggested that the main altarpiece may be slightly later, and comparison with the altars from S. Benedetto Po (Plates 30 and 30a) confirms this; it may have been painted in 1565, at which date Veronese received payment for unspecified work that probably included the lateral canvases (Plates 37 and 38). The altar is flanked by frescoes of *SS. Paul and Honofrius*, and the scheme was originally completed by the *Assumption of the Virgin, God the Father, Angels, Doctors of the Church* and *Evangelists* which were replaced by Sebastiano Ricci in c. 1700 when the cupola threatened to collapse.

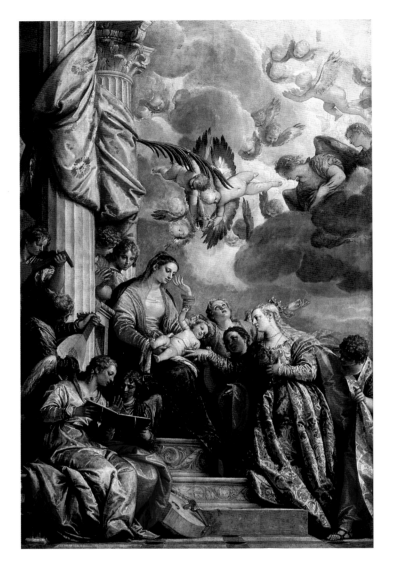

36 *The Mystic Marriage of St. Catherine*
VENICE, Gallerie dell'Accademia. 377 x 242 cm.

The chancel and high altar of Santa Caterina, whence the altarpiece was removed in 1911, were rebuilt in the late seventeenth century. The festive mood fits with the great canvases of the 1560s. The angels singing from their open score to a lute accompaniment were a response to the convent's own music-making, represented in the *Barco*, or singing gallery, opposite the high altar. The burst of heavenly light in the upper right celebrates the mystic marriage of the monastery's name-sake St Catherine, her brocade decorated with blue, gold and yellow with a golden cloak draped over her shoulders as she extends her right hand to Christ, balanced on the lap of the Virgin, raised on steps and framed by twin columns with a festive red drape. Veronese's earliest *Mystic Marriage* was the private devotional canvas formerly in the Hickox collection, New York, now on loan to the Yale Art Gallery, New Haven, whose landscape links with those at Villa Barbaro, Maser (Plates 17 and 21). This suggests a date in the early 1550s. There are two workshop variations on the ex-Hickox painting, in a private collection, Scotland and in Tokyo.
.

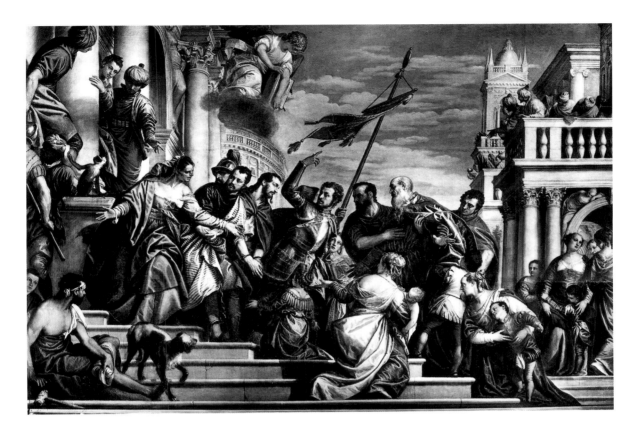

37 *St. Sebastian exhorts SS. Mark and Marcellian to
their Martyrdom*
VENICE, S. Sebastiano. 355 x 450 cm.

This, the left hand of the two lateral altars in the main
chapel, was probably part of the work for which
Veronese received payment in 1565. The story is based
on the *Golden Legend* like the *Martyrdom* opposite (Plate
38) The *Golden Legend* is a compilation of saints'
legends assembled at the end of the thirteenth century
by Jacobus de Voragine. It remained immensely
popular during the fifteenth and sixteenth centuries
when published editions rivalled the Bible in
popularity. According to the Golden Legend the twins
Mark and Marcellian were about to be martyred when
they were begged not to, first by their mother, then by
their father and finally by their wives with their
children; St. Sebastian was present, still in the Imperial
army, and his eloquence, symbolized by his upraised
arm and the Bible carried by the angel, prevailed. The
picture reworks the traditional formula employed by
Carpaccio with a lower viewpoint and elegant
architecture which is masked by the figures at the point
where it would establish real depth; it may also be a
critique in Venetian terms of Federico Zuccaro's
Raising of Lazarus of about 1563 in the Grimani chapel
in S. Francesco della Vigna. The Zuccaro could have
suggested both the composition and the gesture of the
mother on the left who recalls the man with his arms
spread wide in the *Raising of Lazarus* just as St.
Sebastian's upraised arm may have been inspired by
Christ's imperious gesture. The mother kneeling on the
steps seen from the back and the careful alignment of
the heads give Veronese's composition a fluency which
contrasts with Zuccaro's comparatively isolated figures.

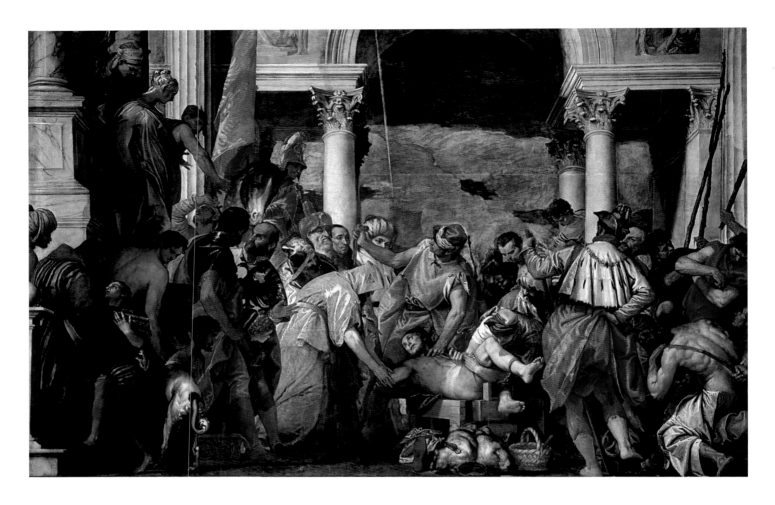

38 *Martyrdom of St. Sebastian*
VENICE, S. Sebastiano. 355 x 540 cm.

This, the right hand of two lateral canvases in the main chapel, was also planned to be viewed by the spectator standing on the steps of the altar rails. It shows St Sebastian's martyrdom, after the failure of the efforts to shoot him to death with arrows. The picture, is lit from the altar windows so that the group around the idol is in shadow, an extension of the formula first used in *Sebastian before Diocletian*

(Plate 13). The composition develops that of the *Martyrdom of SS. Primus and Felician* of 1562 now in the Museo Civico, Padua; the extra attendants turn their backs on the spectator to concentrate attention upon the saint whose twisting prose reflects that of the St. Lawrence in Titian's *Martyrdom of St. Lawrence* in the Gesuiti, Venice (Plate 38a). St Sebastian does not acknowledge the burst of heavenly light signifying his triumph, but turns his gaze to the *Virgin and Child Appear to SS. Sebastian, John the Baptist, Peter, Catherine and Elizabeth* on the main altar (Plate 35).

38a TITIAN
Martyrdom of St. Lawrence, detail
VENICE, Gesuiti.

39 *Martyrdom of St. George* (right)
VERONA, S. Giorgio in Braida. 426 x 305 cm.

Following the death of Sanmicheli in 1558 the frame
of the main altar in the church of San Giorgio in
Braida was executed by Bernadino Brugnoli, in time
for Daniele Barbaro to admire it in December 1563.
The traditional date of 1566, first suggested for the
Martyrdom of St George in the nineteenth century,
appears to be confirmed by the drawings.
Veronese painted the *Miracle of St. Barnabas* now in

Rouen for S. Giorgio at the same time; the moment
chosen also shows his interest in the *Golden Legend*
according to which St. Barnabas took the gospel of St.
Matthew with him to Cyprus with which he cured the
sick. The temple in the background of the Musée des
Beaux-Arts, Rouen canvas recalls Bramante's *Tempietto*,
in S. Pietro in Montorio in Rome, see Cocke, 1984. 52
and 53, but the use of the Corinthian order suggests
the example of the temple of Periptery that Palladio
had designed for Book VI of Barbaro's edition of
Vitruvius.

40 *Assumption of the Virgin*
VENICE, SS. Giovanni e Paolo, Cappella del Rosario. 762 x 432 cm.

This was the central oval of the ceiling of the Jesuit church of Santa Maria dell'Umiltà, near the Salute. The church was reconstructed following the fire of 1543 and on completion in May 1564 the ceiling was described as 'a great success (riuscito molto bene); the whole city came to see it'. The complex was completed by the *Annunciation* over the entrance and *Adoration of the Shepherds* towards the altar, where the Virgin raises Christ to underline the connection with his latter-day namesakes, the Jesuits. The present arrangement, which dates from 1926, after their return from Vienna, does not allow the spectator to stand back far enough to achieve the correct viewpoint. The *Assumption of the Virgin* was later reworked in the high altar from Santa Maria Maggiore, now in the Gallerie dell' Accademia, commissioned by Simone Lando by 1584.
See: Rearick, 96.

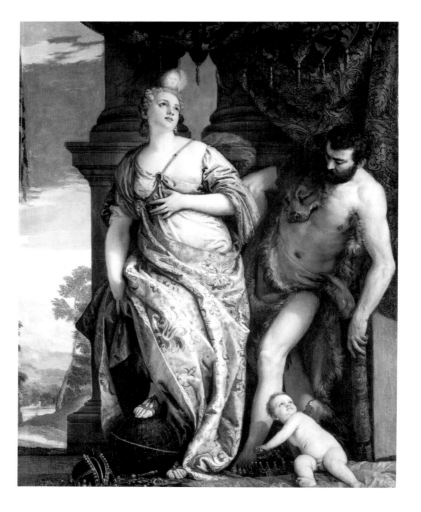

41 *Omnia Vanitas*

NEW YORK, Frick Collection. 214.6 x 167 cm.

This and the *Honor Et Virtus Post Mortem Floret* (Plate 42) were included in a list of paintings in Venice among the papers relating to Jacopo Strada in the Staatsarchiv, Munich. Strada was active on behalf of Albrecht V of Bavaria during 1567 when he made a number of purchases for the Bavarian Court. The picture's meaning, established by the Biblical tag, refers to the vanity of love (Cupid), of the world, of jewels and of sceptres; the melancholic mood of Hercules as he looks at the globe associates him with these vanities and he probably represents a search for wisdom, a view which started with Mythographus III but with which Veronese may have been familiar through Bocchi's *Symbolicarum Quaestionum* (see P. 1977, p.120

ff.). The woman appears to be excluded from the gloom and her attributes, the globe at her feet and the sun (the light of God) above her head identify her as truth just as her upward glance and the gesture of her left arm underline her connection with Christian faith. The imagery fits with Albrecht's defence of the Catholic cause, and could be intended as a warning to his son and the young bride whom he married in 1568, not to value too highly the many costly jewels that they were given as wedding presents. It was subsequently no. 1212 in the 1621 Prague inventory of Rudolph II's collection; captured by the Swedes in 1648, it passed with Queen Christina to Rome; it was then in the Orléans collection in 1721 until sold in England to Thomas Hope of Reepdene in 1799. It was acquired by the present collection in 1912.

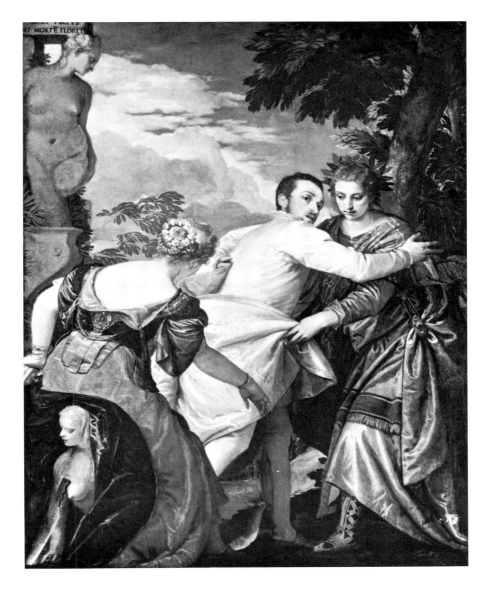

42 *Honour and Virtue Flourish after Death*
NEW YORK, Frick Collection. 219 x 169.5 cm.

This picture, like the *Omnia Vanitas*, was included in the list of paintings among Strada's papers and had the same subsequent history. The imagery is an adaptation of the Choice of Hercules, whose sense is given by the inscription; the lascivious lady on the left is death and the young man, presumably honour, escapes from her attentions into the arms of Virtue with nothing worse than a tear in his stockings. The picture may have been intended as a valedictory blessing on the young couple, who were about to be married in 1568 by the forty-year old Elector, who intended their honour and virtue to flourish after his death. The laurel and the emphasis upon life and death in the two canvases echoes one of the *imprese* on the banners at the marriage; a lion seated under a laurel tree crowned himself with laurel decorated with diamonds and gold and the motto was 'IN VITA ET IN MORTE' (In Life and in Death).
See: K. Garas, 'Veronese e il collezionismo del Nord nel XVI-XVII Secolo' in Gemin, 16-18

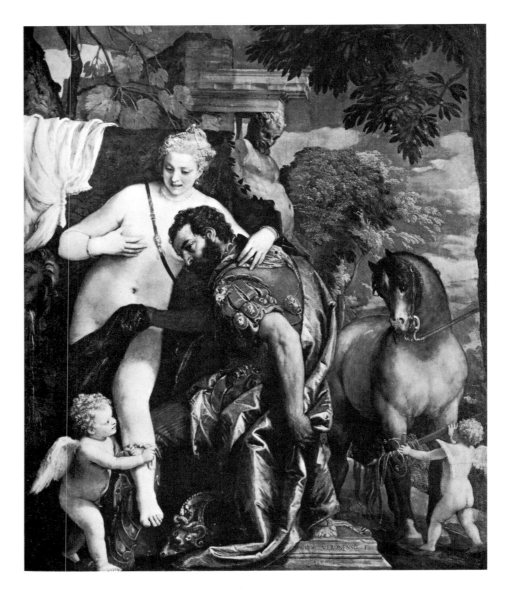

43 *Mars and Venus Bound by Cupid*
NEW YORK, Metropolitan Museum. 205.7 x 161 cm.

The picture is first certainly mentioned in the inventory of the Emperor Rudolph's collection in Prague drawn up by the Swedes in 1648, which also included another version of which only fragments survive. One of these pictures was no. 1151 in the 1621 inventory but it is impossible to decide which; its subsequent history was similar to that of *Mercury, Herse and Aglauros* (Plate 52) except that it passed through a number of English private collections in the nineteenth century before being acquired by the museum in 1910. The contrast between the clothed Mars and the naked Venus goes back to a classical tradition which Mantegna had revived in his *Parnassus* now in the Louvre.

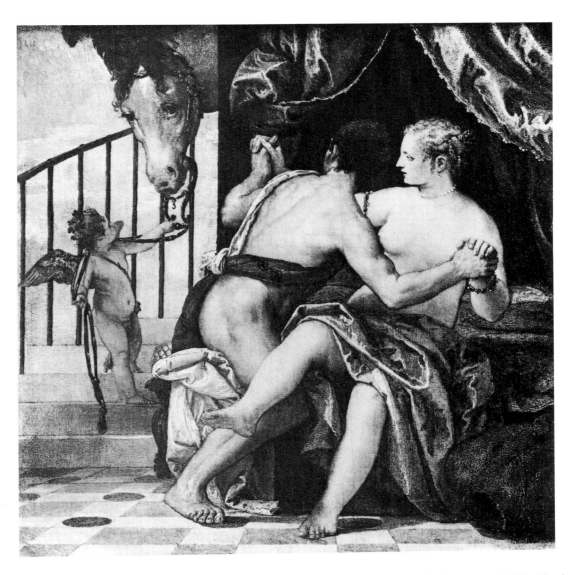

44 *Mars and Venus*
TURIN, Galleria Sabauda. 47 x 47 cm.

This is perhaps the wittiest of all Cinquecento paintings in its deflation of the suggestive mood of the subject; the later version in Edinburgh shows Mars about the remove a shawl from Venus's breasts but it too shares this defusion of the potential eroticism through Venus's smiling involvement with Cupid at her feet. The picture which was first noted in the Orsetti collection was in that of Faustino Lechi by 1768; it was bought by Richard Pryor in 1802 and subsequently appeared in the sale of Sir Thomas Lawrence's collection. It was in an anonymous sale at Christies, London, in 1907 and in the Gualino collection, by whom it was presented to the Gallery, by 1924.

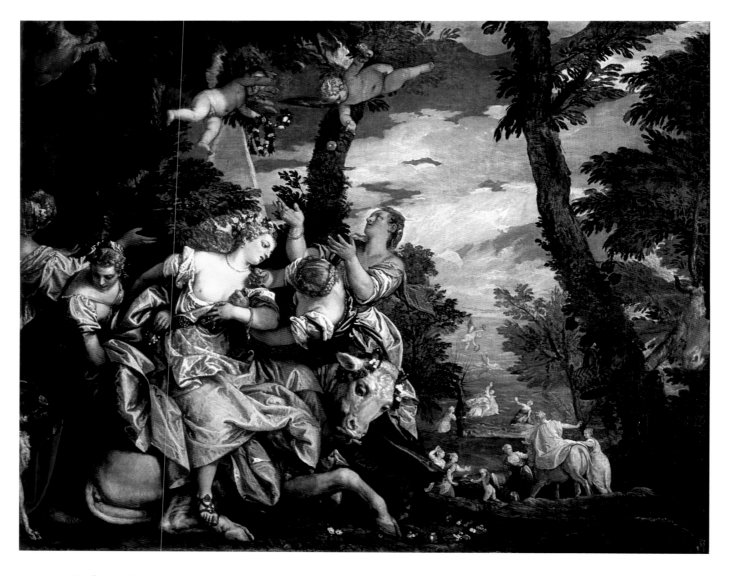

45 *Rape of Europa*
VENICE, Ducal Palace, Anticamera of the Sala del Collegio. 240 x 303 cm.

This was painted for Jacopo Contarini in 1573. Contarini was a protégé of Daniele Barbaro, a distinguished administrator and collector with an especial interest in Francesco Bassano, Palma Giovane and Palladio, whose drawings he inherited. He was responsible for the decorations to celebrate Henry III's visit to Venice in 1574, which included Veronese's and had helped to draw up the programme for the Sala del Maggior Consiglio, persuading Veronese to undertake the *Venice Triumphant* (Plate 58). *The Rape of Europa* was presented to the Venetian republic in 1713 and was a reworking on a grander scale of the small canvas in the Rasini collection, Milan, probably commissioned to celebrate a wedding.
See Cocke, 1984 64

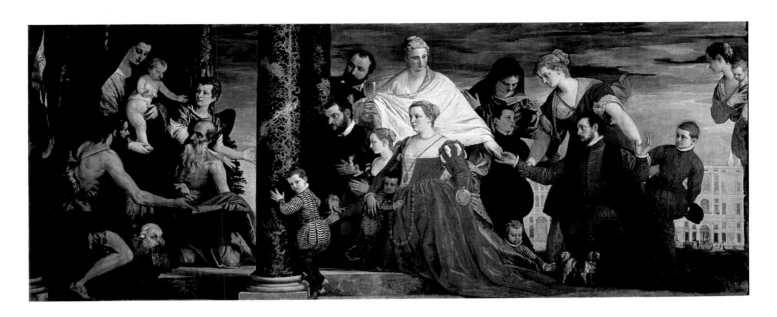

46 *Virgin and Child with SS. John the Baptist, Jerome and the Coccina Family*
DRESDEN, Gemäldegalerie. 167 x 416 cm.

The families of Alvise, Antonio and Zuanantonio Coccina are presented to the Holy Family by Faith, Hope and Charity while the saints and the angel in the background intercede on their behalf. The youngest child, Zuambattista, was born in c. 1570 while Antonio died in August 1572 which suggests that this, one of four paintings for the family, was painted in 1571. They were acquired for the ducal collection, Modena in 1645 and then by the Elector Frederick August III of Saxony in 1745. The Coccina family palace which had been built by Giacomo di Capponi by 1563 is shown in the background behind the families but the twin marble columns separate the Coccinas from the heavenly sphere, a sense of decorum that marks a development from the Louvre *Supper at Emmaus* (Plate 25). The immediate prototypes lie in the sixteenth century, Titian's lost *Votive Picture of Doge Andrea Gritti* and Tintoretto's *Virgin and Child with SS. Sebastian, Mark, Theodore and a Group of Treasurers* in the Accademia, Venice, of 1567, but the clarity of the distinction between the earthly and heavenly zones may reflect Altichiero's late fourteenth-century *Members of the Cavalli Family Presented to the Virgin and Child* in S. Anastasia, Verona, albeit with very different architecture.

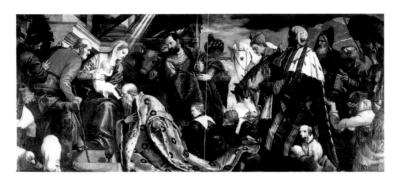

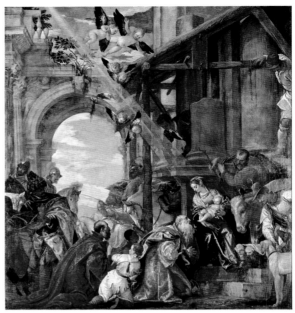

47 *Adoration of the Magi*
DRESDEN, Gemäldegalerie, 206 x 455 cm.

This the second of the four canvases commissioned by
the Coccina for their family palace on the Grand Canal.
The *camera grande* on the first floor, the only room large
enough for paintings of this scale, must have been
divided by doors in the centre of the two long walls.
The *Adoration of the Magi* probably hung on the same
wall as the *Virgin and Child with SS. John the Baptist, Jerome
and Coccina Family*. The family's small lapdog, on the left,
looks out of the canvas to the pair of dogs seated
behind the magi in the *Adoration of the Magi*. One of
these looks out at the sheep sketched on the distant hill,
seen under the leading horse, while his companion looks
diagonally across, presumably at the family cat petted in
the *Marriage Feast at Cana*. Seen alongside the *Coccina
Family* there would have been a poignant contrast
between the family, cut off in their devotion and the
magi, kneeling before the Virgin and Child, spotlit
against ruins, their humility offset by the unparalleled
virtuosity of their costumes. The first of the standing
magi wears a rich red cloak and the oriental king one of
shimmering pink and green silks with a fur trim,
costumes which were peculiarly appropriate for wealthy
merchants, who had bought Venetian citizenship.
See Cocke, 1984, 60

48 *Adoration of the Magi (above)*
LONDON, National Gallery. 355 x 320 cm.

Veronese's great canvas was commissioned by the
Scuola di S. Giuseppe in 1573 (the date given in
Roman numerals on the canvas) while Antonius
Cassianus was prior (1572-1577). It was designed to be
viewed from the left, suggesting that it served as a
lateral canvas -not related to an altar- balanced on the
other side of the main altar by the now lost *Marriage of
St Joseph* by Camilio Balin. Veronese extended the
composition of the earlier *Adoration of the Magi*
painted for the Coccina family (Plate 47) to fit both
this huge canvas and that commissioned in the same
year for Antonio Cogollo's family chapel in Santa
Corona, Vicenza
See Cocke, 1984, 66, 67 and 68.

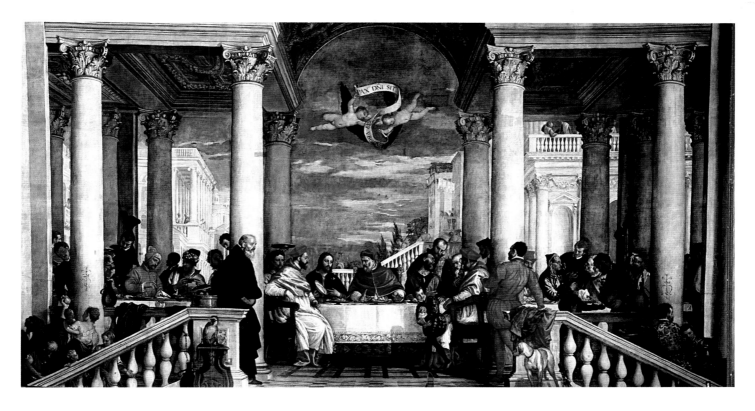

49 *Feast of St. Gregory the Great*
VICENZA, Santuario di Monte Berico. 477 x 862 cm.

The sanctuary of the Madonna at Monte Berico, built
as a plague church, in response to a vision of the
Virgin in 1428, was handed to the Servites in 1435.
The Veronese Damianus Grana, prior from 6 May
1571 until 28 October 1573, commissioned the *Feast*
for the refectory (subsequently rebuilt) and Veronese
received the final payment of 600 ducats on 29 April
1572. The recent cleaning and restoration undid the
damage inflicted by Austrian troops on 10 June 1848.
They extended suppression of Italian revolution to
exemplary damage of the *Feast*. This was first cut it
into five or six large pieces, and then into thirty-two
smaller ones.

The choice of subject from the *Golden Legend* reflects
that it was a pilgrimage church. Every Friday St
Gregory entertained twelve pilgrims, but
on one occasion was suddenly aware of a thirteenth –
the number here – unnoticed by anyone else. Another

time St Gregory turned to offer water to the pilgrim
sitting next to him, only for him to disappear before
returning to reveal his identity – Christ. Veronese rose
to the challenge of rendering disappearing pilgrims by
showing Christ holding a bowl up for St Gregory, but
cut off from the mundane world on the staircases,
including Damianus Grana, standing in front of a
mother and child receiving charity, to stress the
Servites' good works. The pose, gesture and intense
stare of the servant in front of the column reveal that
he shares the pope's awareness of Christ's miraculous
appearance, by contrast with the doubts of the
cardinal in front of him, raising his eye-glass to
inspect the interloper. The miracle is further empha-
sised by the angels holding the inscription 'PAX
D[0MI]NI SIT SE[M[P[ER] [VO]BISCU[M] (May the
Peace of the Lord always be with you), which alludes
to St Gregory's celebration of mass at S.Maria
Maggiore, when according to the *Golden Legend*, an
angel gave the response – 'and with your spirit' to the
pope's 'Peace be with you.

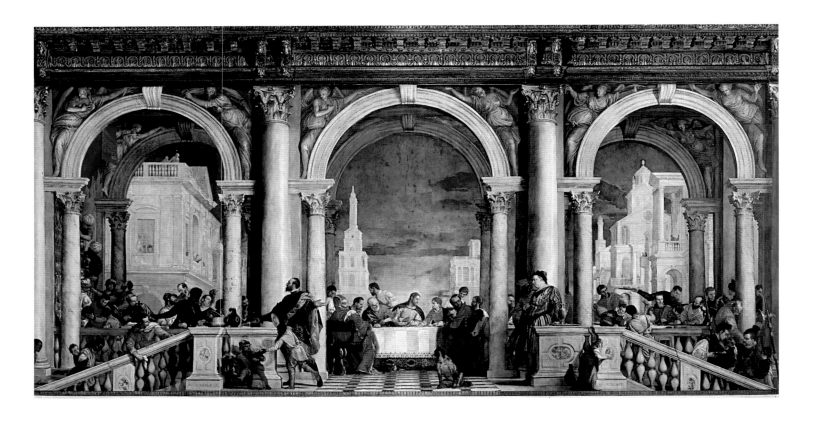

50 *Feast in the House of Levi*
VENICE, Gallerie dell'Accademia. 555 x 1280 cm.

The picture which is inscribed: 'A.D. MDLXXIII DIE XX APR' and 'FECIT. D. COVI MAGNU LEVI LUCAE CAP V' was painted for the refectory of SS. Giovanni e Paolo to replace a *Last Supper* by Titian which had been destroyed by fire in 1571. Veronese appeared before the inquisition to answer questions about the picture on the 18th July 1573 (the text is transcribed by Fehl, *Gazette des Beaux Arts*, 1961, p. 325 ff.); the outcome was a compromise, for the picture does not fit with the passage in Luke, which was later the subject of a dull picture by his heirs from the refectory of S. Jacopo on the Giudecca, now in the Palazzo del Gran Guardia, Verona. The inscription takes care to back-date the new title to April, when the picture must first have been unveiled.

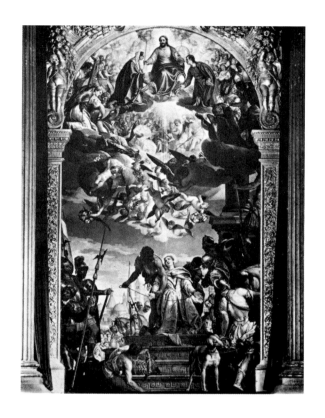

51 *Martyrdom of St. Justina*
PADUA, S. Giustina. 525 x 240 cm.

The picture, as Carlo Ridolfi noted in his extended biography of Veronese included in *Le Maravaglie dell'Arte* (first published in Venice in 1648), is almost invisible because of the poor lighting. The church of S.Giustina has been commenced in 1509, and was finished in c. 1580. The altar was built in 1560 and Veronese, together with his brother Benedetto, (who in spite of the popular view to the contrary can have had little to do with the present canvas) is documented as present in Padua in 30 March 1575; by the 27 October of that year he had entered into an agreement with the monks of S. Giustina to provide them with an altar for the Church of Conca, by which date he had, presumably, completed the present altar. The choice of moment with the saint kneeling in intercession to the Deësis does not follow the legend of her martyrdom, which is celebrated on October 7th, but appears to be inspired by the *Martyrdom of St. George* (Plate 39). According to legend St Justina had been stopped on a bridge over the Po whilst on her way back to Padua from the countryside. She knelt before Maximian in prayer to preserve her innocence, but was stabbed in the throat with a sword. Veronese had based the *Martyrdom of St Justina*, now in the Gallerie degli Uffizi, Florence, on the legend probably as early as 1556.
see: Cocke, 1984, 75

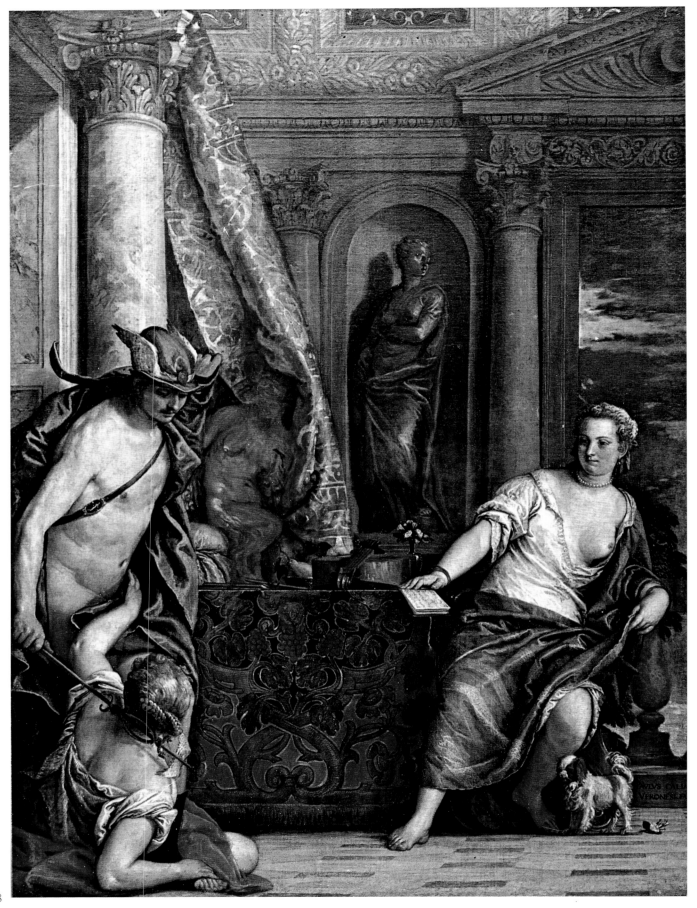

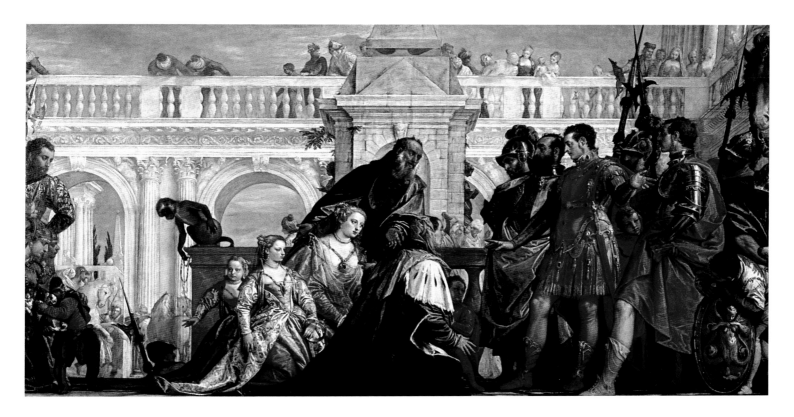

52 *Mercury, Herse and Aglauros* (left)
CAMBRIDGE, Fitzwilliam Museum. 232 x 173 cm.

53 *The Family of Darius before Alexander* (right)
LONDON, National Gallery. 236 x 474 cm.

The early history of this canvas is unknown; it was no. 1193 in the 1621 Prague inventory of Rudolph II's collection; it was bought by Viscount Fitzwilliam who bequeathed it to the museum in 1816. The choice of the climactic moment in Ovid's account in book II of the *Metamorphoses* is unusual; Pordenone had shown the earlier moment when the flying Mercury first sees Herse on the facade of Palazzo d'Ana that is recorded in a drawing in the Victoria and Albert Museum. The illustrated editions of Ovid, exemplified by the woodcut that accompanied Dolce's 1553 translation, showed the first encounter between Aglauros and Mercury outside the palace.

Traditionally dated to the late 1560s or early 1570s, although the circumstances of its commission remain unclear. It was first noted in 1648 in Casa Pisani, Francesco Pisani's house in the Procurators of St Mark's, later being transferred to the family palace at San Polo. In 1661, when Paolo del Sera valued it at five to six thousand ducats, the Pisani were wealthy enough not to sell it to the French agent acting for Cardinal Mazarin. Count Vettor Pisani finally agreed to sell it to the National Gallery in 1857 for 15,000 Napoleons, the second highest price ever paid for a canvas.

X-rays show the certainty with which Veronese established the setting and the figures, changing the intrusive figures and balustrade to the right of the central fountain.
See: Penny I

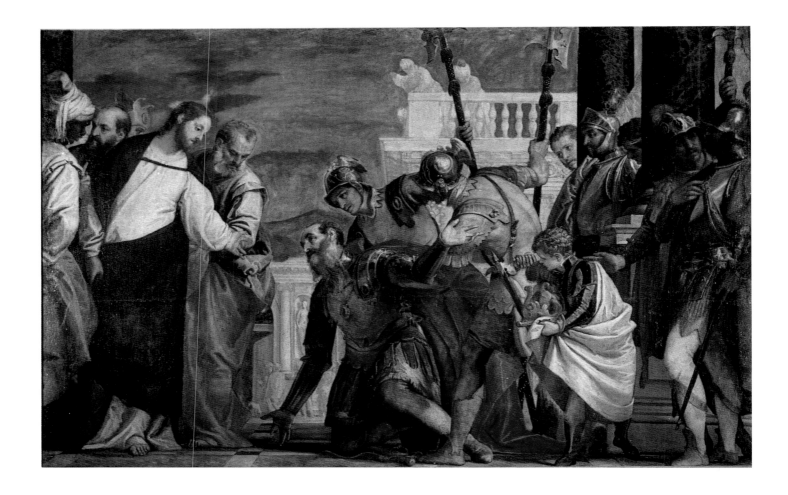

54 *Christ and the Centurion,*
MADRID, Museo del Prado, 192 by 297 cm.

This was commissioned, probably in the later 1560s, by the unidentified bearded donor immediately behind Christ. The balustrade and columns, which recall the background in the *Family of Darius before Alexander* (Plate 53), frame the centurion, supported by two of his soldiers as he kneels before Christ to indicate that he is unworthy. He had asked Christ to heal his sick servant and then responded to Christ's reply that he would come to the centurion's house 'I am not worthy that thou shouldest come under my roof; but speak the word only, and my servant shall be healed. For I am a man under authority...and I say to this man Go, and he goeth.' Christ's gesture suggests the response 'he marvelled, and said to them that followed, Verily I say unto you, I have not found so great faith, no not in Israel' (Matthew 8, 5-11) The *Christ and the Centurion* was acquired for the Spanish Royal collection from the sale of the Earl of Arundel's collection, where it was either 410 (the 'great' centurion) or 411 (the 'small' centurion) in the 1655 inventory made in Antwerp. Its success is demonstrated by the later workshop versions, beginning with that in Dresden and including others in Kansas City, Munich, Vienna and Toledo.

55a *Bust of Allessandro Vittoria*

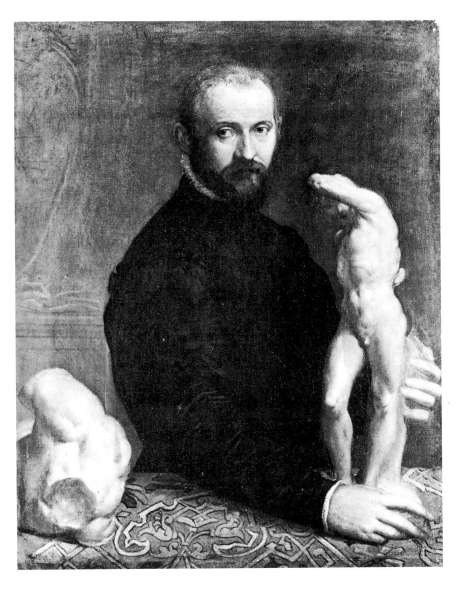

55 *Portrait of Allessandro Vittoria*
NEW YORK, Metropolitan Museum. 110 x 77 cm.

The picture, which was sold from the Brownlow collection at Christies in 1923 was bought by the museum from an Italian collector in 1946. The identification, first proposed by A. M. Frankfurter, is supported by a comparison with the bust on Vittoria's tomb in S. Zaccaria (Plate 49a) and by the fact that the *modello* of St. Sebastian that he holds relates to Vittoria's bronze in the Metropolitan Museum. Vittoria cast bronze St. Sebastians in 1566 and 1575; comparison with his portrait by Morone, now in Vienna, which has convincingly been dated to 1552–53, shows him as much older and the New York portrait is therefore likely to date from 1575. Veronese had worked with Vittoria in the 1550s both at Maser and at Palazzo Trevisan and the expressive possibilities of the St. Sebastian influenced his own version of this figure on the right of *Doge Sebastiano Venier's Thanksgiving for the Battle of Lepanto* (Plate 57)
.

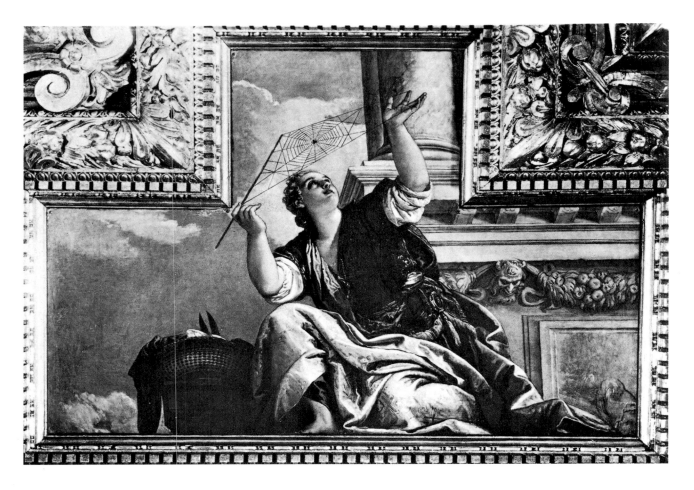

56 *Justice and Peace before Venice: Industry*
VENICE, Ducal Palace, Sala del Collegio.
250 x 180 cm., and 150 x 220 cm., respectively.

The decoration of the Sala del Collegio was destroyed by fire in 1574 and the redecoration began at once. Veronese received his first payment in December 1575, although the account book breaks off in 1577, before the final payment. *Justice and Peace* was over the Tribunal with *Faith* in the centre and *Mars and Neptune* towards the doors. These allegories have both a general and a specific application to the Collegio which was responsible for the business of the Senate (the supreme legislative body): *Justice and Peace* alludes to this function, *Mars and Neptune* refers to its role as the Ministry of War and *Faith* to its responsibility for religion. These canvases were accompanied by pairs of allegorical ladies; reading from the entrance they are: *Liberality* (the eagle giving up a feather) and *Fortune* (holding out the dice); *Industry* (Plate 56) (the spiders' reputation for never ceasing to work goes back to the sixth-century encyclopedia of Isidore of Seville) and *Moderation* (this identification of the character of the ermine, that of the *Fior di Virtù*, seems more relevant in the context of the scheme than the alternative association with chastity); *Vigilance* (the crane) and *Mildness* (the lamb, equated with the lamb of god; *Felicitas Publica (Public Good)* (the Caduceus and cornucopia derived from classical coinage) and *Faith* (the dog, most faithful of animals). The need for the members of the collegio to cultivate these virtuous ends is obvious, and the message of the central canvases was reinforced by a further series of grisailles.

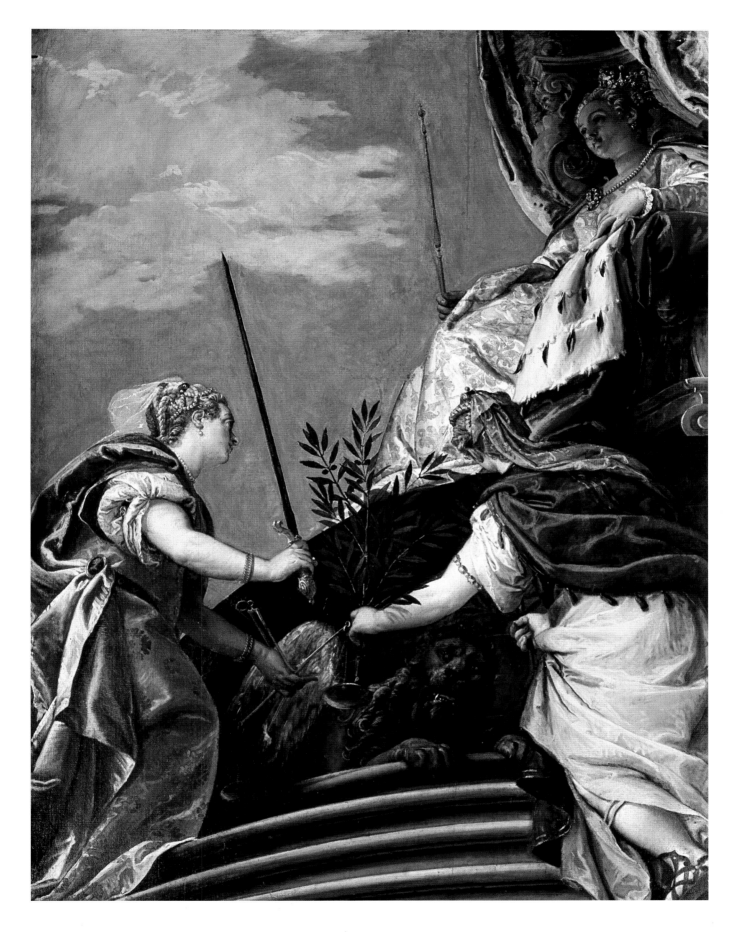

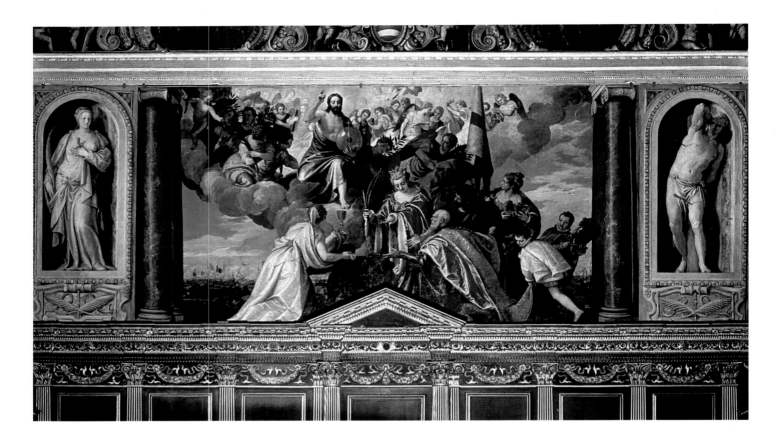

57 *Doge Sebastiano Venier's Thanksgiving for the Battle of Lepanto*
VENICE, Ducal Palace, Sala del Collegio, 285 x 565cm.

Sebastiano Venier had been elected Doge in 1577 but died in March 1578, which must be the dates for the commission of this painting. Venier had been one of the commanders at the Battle of Lepanto on 7 October 1571, and his votive painting recalls that great victory over the Turks. He kneels before S. Justina (on whose saint's day the battle occurred and who is also one of the flanking saints – the other St. Sebastian is Venier's namesake) and the lion of Venice in worship of Christ who is accompanied by angels, while in the background we see the naval battle. To the left Faith kneels with her back to us holding the chalice while St. Mark introduces the Doge; between them can be seen Agostino Barbarigo, the Venetian Proveditor Generale at the battle, while Venice is behind them on the right with two attendants. Sinding-Larsen, J.W.C.I. 1956, 298 ff., noted that the early description of the painting by Sansovino fitted the *modello* in the British Museum, London, not the composition as executed, and argued that the changes in the present canvas were the work of a later artist. Veronese, however, worked with considerable freedom in the *Venice Triumphant* (Plate 58). The plan described by Sansovino must have been felt to be inadequate because the victory was one for the whole of Christendom, not just Venice, and so Christ was a more suitable figure to receive the Doge's thanksgiving than St. Mark. This change further emphasizes the sacramental nature of the chalice, a theme of other late Veronese's, notably *Christ with Zebedee's Wife and Sons* (Plate 60). The *modello* in the British Museum reveals Veronese's share in the changes for in it Agostino Barbarigo is added as an afterthought over the flag between St. Mark and Venice, and St. Justina also appears to have been added later.
See: Cocke, 1984, 86-87.

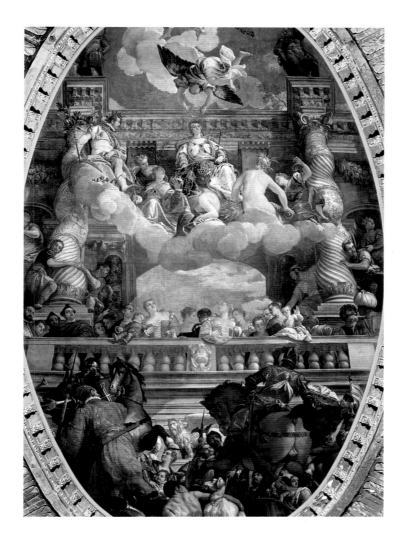

58 *Venice Triumphant*
VENICE, Ducal Palace, Sala del Gran Consiglio.
904 x 580 cm.

The original decoration of the ceiling, which was
destroyed by fire in December 1577, was replaced by a
framework designed by Cristoforo Sorte which was
under way by August 1579, and the scheme of the
decoration was drawn up in the same month (see
Wolters, M.K.I.F., 1965/66, p. 271 ff.). Veronese's
ceiling paintings which were under way by 1582 were
completed by 1584. *Venice Triumphant* is flanked by two
further canvases the *Conquest of Smyrna by Paolo Mocenigo*
and the *Defence of Scutari by Antonio Loredano*, which are
darker and more sombre in their handling, much of

which can be attributed to the workshop. This is a
development that echoes the way in which the darker
flanking canvases in the ceiling from S. Nicolò contrast
with the rich *Adoration* in the centre. This was
intentional, for on the verso of the Oxford drawing
for the *Conquest* is a badly drawn oval, which reflects
the frame of the *Venice Triumphant*. In the *modello* for
the ceiling, which is now in the collection of Lord
Harewood, at Harewood House, guide lines were ruled
on the sheet, the architecture was drawn next and the
figures added at the last stage. There are many minor
changes between the *modello* and the final canvas, one
of which, the lower curve of the main arch, is
indicated in the Oxford drawing.
See: Cocke, 1984, 88, 89 and 90.

59 *SS. Peter, Paul and John the Evangelist*
VENICE, S. Pietro di Castello. 320 x 155 cm.

This, the most romantic of all Veronese's altars was painted at the commission of Giovanni Trevisan, the 13th Patriarch of Venice, for the altar which he dedicated to St. John the Evangelist in his church of S. Pietro di Castello; both altar and altarpiece were completed by 1581. In its present condition the altarpiece, which has been removed from the family altar to a poor position on the north of the nave, is difficult to judge because of the damage most visible in the head of St John. A workshop drawing on the Paris art market in the 1990s accurately copies the Sts Peter and Paul, but shows differences in St John's head and cloak and may reflect the altarpieces's original appearance.

60 *Christ with Zebedee's Wife and Sons*
STAMFORD, Burghley House, Trustees 270 x 150 cm.

The picture, which was painted as the main altar of S.
Giacomo, Murano, probably in the late 1570s was
acquired by the 9th Earl of Exeter in 1769, together
with the *SS. James and Augustine* from the organ
shutters. Both the altar and the organ shutters, which
were completed by a now lost *Mystic Marriage of St.
Catherine*, are, in spite of the doubts to the contrary
expressed by Italian critics, autograph. The choice of

subject is unprecedented in Venetian painting, and
connects both with the picture's function as the main
altar in a church dedicated to St. James, and with the
Catholic devotion to the Host. The S. Giacomo altar
inspired the full-length version in the Musée des
Beaux-Arts at Grenoble, one of the pictures that
Bernini disliked on his visit to Paris in 1665. The
weight and complexity of Christ's robe fits with that of
the paintings in the 1570s, and the stance and gesture
of Zebedee's wife are adapted from that of the
Stamford painting.

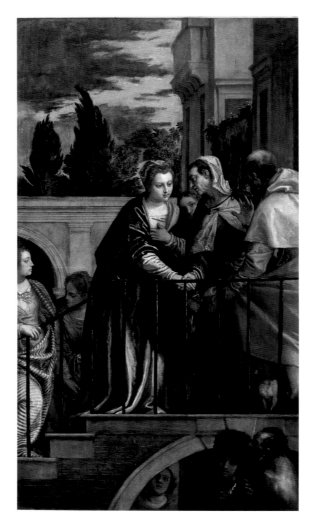

61 *The Visitation*

BIRMINGHAM, Barber Institute. 272 x 152.5 cm.

The picture, one of those painted for S. Giacomo, Murano, has a preparatory drawing formerly in the Koenig collection, Haarlem which included sketches for the Charity that flanked the *Annunciation* in the Scuola dei Mercanti. Charity is further elaborated on another sheet (see: Cocke, 1984, 80) with drawings for the SS. Justina and Sebastian of 1577 and 1578; this must be the date of the present painting and of the other canvases from S. Giacomo which include *Christ with Zebedee's Wife and Sons* (Plate 60) and the *Resurrection* in Westminster Hospital, London. The present canvas was acquired by Lord Clive from Sir James Wright in 1771 and was bought by the gallery in 1953. The action is set on one of the small stone bridges that are a feature of Venice, which may have been inspired by that in the background of Palma Vecchio's version in the Kunsthistorisches Museum, Vienna; it creates space in the foreground for the spectators who witness a *Visitation* carried through with expressive gestures that are matched by the sombre tonality. Both these features recur in the *Thanksgiving of St. Ann and Joachim* in S. Polo where Joachim and Ann kneel in adoration of the image of the Virgin which is borne by the angels. The S. Polo picture, completed by 1581, has suffered but, like the *Visitation*, is most probably autograph.

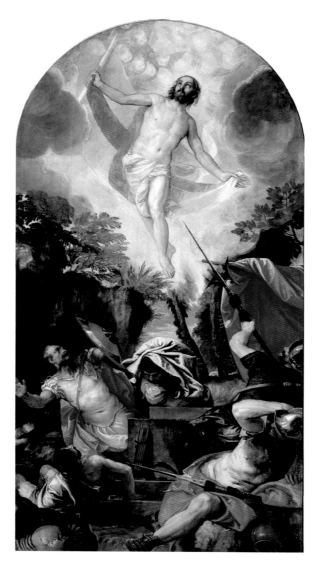

62 *Resurrection*
VENICE, S. Francesco della Vigna. 325 x 160 cm.

The action in the altarpiece in the funerary chapel of Alberto (1540-1592) and Andrea (1515-1575) Badoer takes place at night. The saviour rises triumphantly above the screen of trees, framed by the great banner which heightens the contrast with the burst of light. He is contrasted with the soldiers guarding the tomb, who were developed from a smaller *Resurrection* now in the Gemäldegalerie Dresden. One in the foreground sleeps on his bed-roll, another struggles up from his back, the remainder twist to ward off the light with arms, cloaks (the figure immediately under Christ), halberds and shields.

The chapel was certainly ready by 1582 and the *Resurrection* must have been commissioned after Andrea's death on 11 September 1575, and before 1578, when Alberto returned as ambassador from the court of Philip II of Spain. The following year he moved to the court of Rudolph II for three years, when the Emperor was in touch with Veronese

The *Resurrection* from S. Giacomo, Murano, now Trustees of the Chelsea and Westminster Hospital, was painted on a moderately coarse-woven canvas, with additional strips added at all sides, similar to that of the *Visitation* (Plate 61), whose date of 1578 it must share. X-radiographs and infra red reflectograms made during the 1996-7 cleaning and restoration by Carol Willoughby and Paul Ackroyd showed that Christ's pose and gaze to his right were initially based on the Badoer altarpiece.

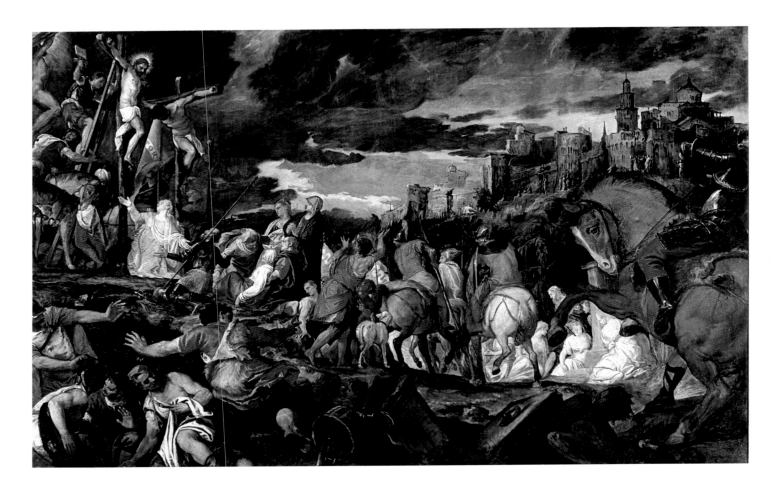

63 *Crucifixion*

VENICE, Galerie dell' Accademia. 287 x 447 cm.

The small oratory of San Nicolò ai Frari, which was destroyed in 1806 to make way for the State Archives, had been re-consecrated on 17 September 1582. This is taken as the date of Veronese's ceiling and wall-paintings. The central *Adoration of the Magi*, now in the Capella del Rosario, SS. Giovanni e Paolo, was flanked by the *Consecration of St Nicholas*, now sadly cut down, over the altar, and the *Stigmatisation of St Francis*, reversed over the entrance, both now in the Gallerie dell 'Accademia, Venice with *Evangelists* in 'L' shaped canvases (also in SS. Giovanni e Paolo). The *Crucifixion* was placed behind the altarpiece, Titian's *Madonna and Child in Glory with Sts Catherine of Alexander, St Nicholas, St Peter, St Anthony of Padua and St Sebastian*, now in the Vatican Galleries, Rome of the 1530s. The *Crucifixion* was flanked by Benedetto's

Christ before Pilate and Alvise dal Friso's lost *Carrying the Cross*. Christ stands out against the dark sky, 'now from the sixth hour there was darkness' (Matthew, 27, 45), adored by the Magdalen and St Longinus, his spear over his shoulder. The ground slopes down from Golgotha, while the horizon is dominated by the walls of Jerusalem. The soldiers gambling for Christ's robe are disturbed by their companion fleeing in horror as the ground opens to reveal 'and the earth did quake and the rocks rent; and the graves were opened and many bodies of the saints which slept arose' (Matthew, 27, 52). When Veronese was commissioned to produce a small version, now in the Louvre, for private devotion he replaced drama with meditation, retaining the crosses set against the dark sky, but simplifying the mourning group and background, where Jerusalem is seen low on the right-hand horizon.

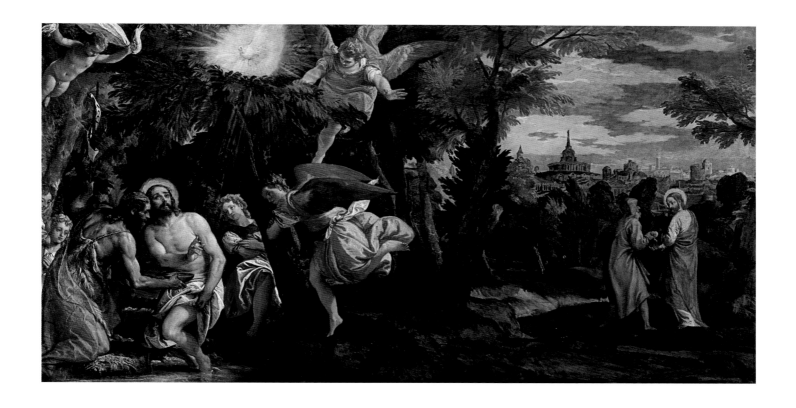

64 *Baptism of Christ*
MILAN, Brera. 248 x 450 cm.

The *Baptism* was commissioned for San Nicolò ai Frari in 1582. It was one of the new lateral altarpieces set at the side of Titian's earlier *Madonna and Child in Glory with Sts Catherine of Alexander, St Nicholas, St Peter, St Anthony of Padua and St Sebastian*, now in the Vatican Galleries, Rome. St John concentrates on the bowl with which he is about to baptise Christ, while Christ looks up 'and lo the heavens opened unto him, and he saw the spirit of God descending like a dove...and a voice saying: This is my beloved Son' (Matthew 3, 16-17). Christ's role was reversed in Benedetto's *Last Supper and Christ Washing his Disciples Feet*, now in the Capella del Rosario, SS. Giovanni e Paolo, originally set above the *Baptism*. The institution of the Last Supper – 'This is my body' was similarly related to Christ's refusal to turn stone into bread in the *Temptation*, set in a clearing in the extensive landscape, over which we see the temple at Jerusalem.

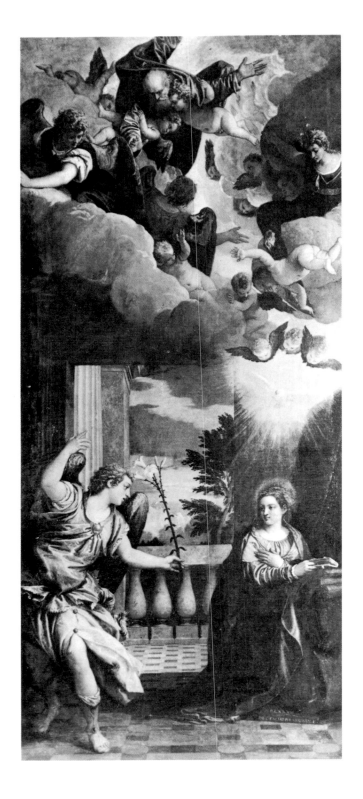

65 *The Annunciation*
EL ESCORIAL, Nuevos Museos.
470 x 206 cm.

The picture, which is signed and dated 1583, was brought
to Spain from Italy in the year in which it was painted,
together with Tintoretto's *Adoration of the Shepherds*. Both,
according to an old and reliable tradition, were originally
intended as a part of the main altar, but both were
replaced. The Tintoretto was rejected because the figures
were judged to be too small, but Veronese appears to have
been given the wrong measurements since the *Nativity* by
Pellegrino Tibaldi which replaced it was over a hundred
centimetres shorter. Philip II of Spain was keen that the
complex be painted by one artist, commissioning first
Federico Zuccaro, whose canvases were rejected, and then
Pellegrino Tibaldi. The early sources refer to the Veronese
with understandable admiration, and in this their
judgement is preferable to the modern view which
consigns it to the workshop. No other Veronese is known
to have been in Spain at this time and it must have
influenced the decision in 1585 to approach Veronese to
work at El Escorial instead of Federico Zuccaro (S.
Saarrablo Aguareles, *Revista de Archivos, Bibliotecas y Museos*,
53, 1956, p. 663). The *Annunciation* from the Scuola dei
Mercanti of 1577–78 stood over a doorway which
explains the emphasis upon the bravura architecture,
which is repeated in the smaller version on the London
market in the late 1970s. The slighter figures and view of
a building freely inspired by Sansovino's Library suggests
an earlier date for the version in the Thyssen Collection,
Madrid, while that in the Cleveland Museum of Art is a
simplified version of the El Escorial canvas.

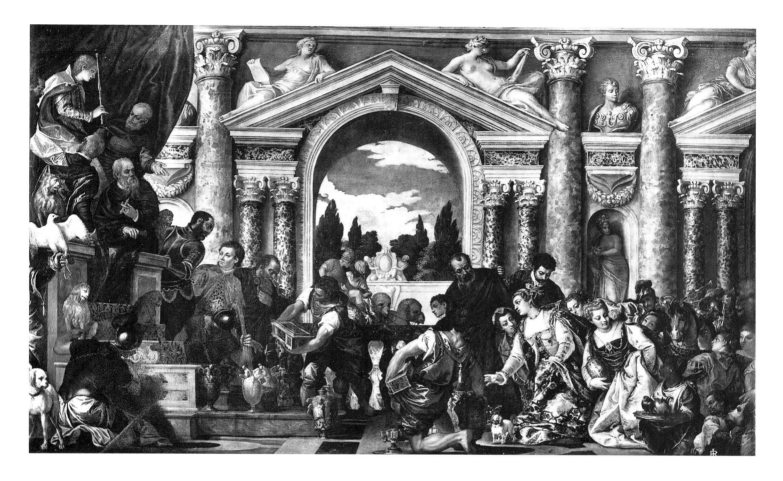

66 *The Queen of Sheba before Solomon*
TURIN, Galleria Sabauda. 344 x 545 cm.

The *Queen of Sheba* was completed for Charles Emanuel I of Savoy by 1582. Francesco Barbaro (b.1546), the Venetian ambassador and son of Marcantonio Barbaro (responsible for the frescos at Maser (Plates 15-21) may have been responsible for the commission and could be the wise counsellor holding a cross. It was accompanied by a lost *Adoration of the Magi* and another, now lost, pair *David with the head of Goliath* and *Judith*. The type of flattery used in the picture is not new. In 1559 the Flemish artist Lucas de Heere produced a version of the subject in which the Solomon is a portrait of Philip II of Spain; Veronese's approach is subtler for the youthful Solomon alludes to Emanuel without (to judge from his coins) being a portrait. The flattery was continued in the now lost *Adoration of the Magi*, a picture traditionally coupled with the *Queen of Sheba*. Ruskin's enthusiasm for the canvas, which needs cleaning, is preferable to the modern view which sees here the hand of Benedetto.

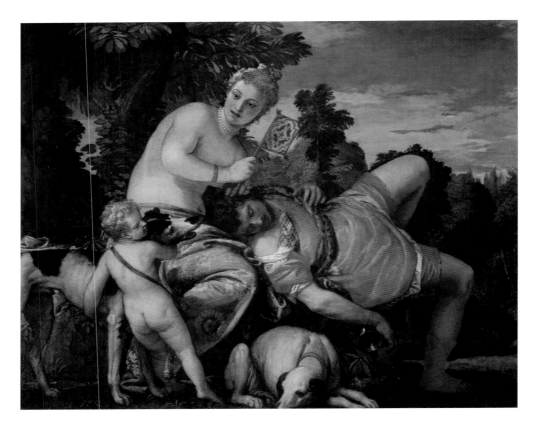

67 *Venus and Adonis*
MADRID, Museo del Prado. 212 x 191 cm.

This, together with the *Cephalus and Procris*
(Plate 68), was one of the pair of paintings which, in
1584, Veronese is reported as having just painted
(specifically *not* for the Emperor Rudolph II) and
which remained in Venice until they were acquired by
Velazquez on his second visit to Italy in c. 1650; it was
no. 595 in the Spanish Royal collection at the Alcázar
in Madrid in 1666. It is possible that the paintings were
produced for stock and that they remained in the
family collection like the slightly smaller *Venus and a
Satyr* which had been painted by 1571. The earlier
version in Augsburg, Staatliche Kunstsammlugen,

where the rich colour with the deep red of Adonis's
robe set against the blue of the sky and the screen of
trees that isolates the figures recall the 1573 *Rape of
Europa* (Plate 45), reflects Titian's *poesie* for Philip II in
the choice of moment with Adonis about to depart for
the hunt. The idyllic mood of the Prado version
reflects the illustrated editions of Ovid and contrasts
with the coarseness, both in choice of moment and
execution of the versions in the Seattle Art Museum
and the Kunsthistorisches Museum, Vienna, by
different members of the workshop.

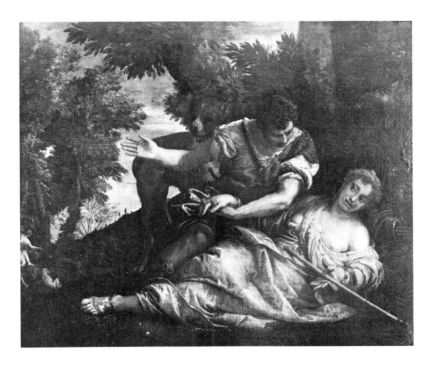

68 *Cephalus and Procris*
STRASBURG, Musée des Beaux-Arts. 162 x 190 cm.

68a *Death of Procris*
La Metamorphose d'Ovide figurée, Lyons, 1557, f. 7v.

The picture, the companion to the *Venus and Adonis* (Plate 67) which was cut down in the nineteenth century. Had the same history as the *Venus and Adonis* probably being no. 601 in the 1666 inventory of the Alcázar where it remained until 1784. It was transferred to the Palacio de Buenvista in 1809 (see M. Lorente Junquera, *Archivo Espanol de Arte*, 1969, 235–243) and removed by Joseph Bonaparte from whose collection it was sold, London 1845 and then again in 1851; it was acquired by the museum in 1912. The figures derive from those in the woodcut of this subject in the 1557 Lyons edition of Ovid (Plate 68a) which may first have inspired the small version formerly in the Holford collection, London.

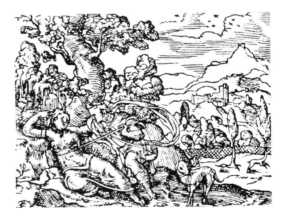

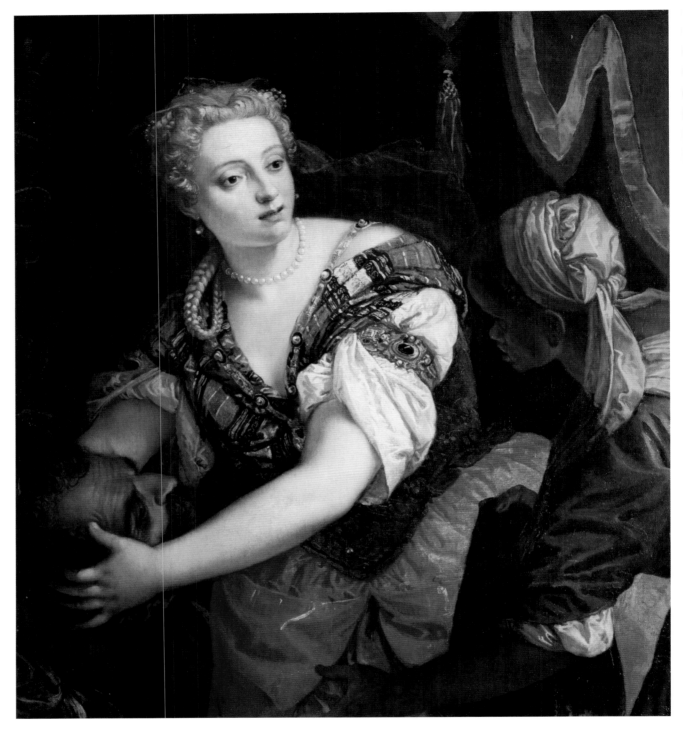

69 Judith
VIENNA, Kunsthistorisches Museum. 111 x 100.5 cm.

This outstanding late picture was first recorded in the collection of Archduke Leopold Wilhelm in 1659, which formed the basis of the Vienna collections. The earliest version of this subject is that now in Genoa, which is badly rubbed, but which must have been painted early in the 1560s, since it inspired Zelotti's canvas of this subject on the ceiling of the Library at Praglia.

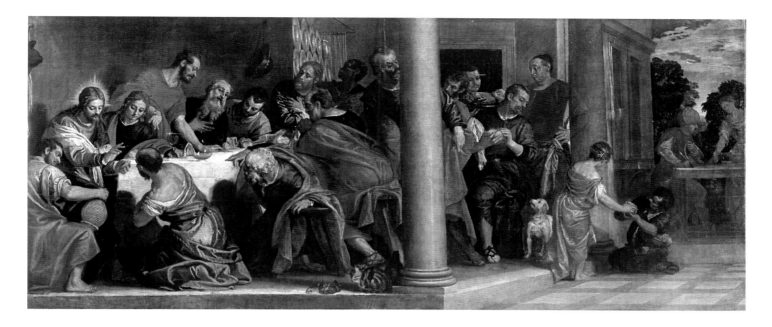

70 *Last Supper* (above)
MILAN, Brera. 230 x 523 cm.

71 *Finding of Moses* (overleaf)
MADRID, Museo del Prado. 50 x 43 cm.

Painted at the commission of the Scuola del Sacramento, Santa Sofia, Venice and removed to the Brera in 1811. Although first mentioned over the entrance, opposite the main altar, it was designed as a lateral, so that Christ is seen over the kneeling apostle. It must have been ready by 1583, by which date the school produced a version for the Cappella del Santissimo, S. Giuliano, which depends upon this painting. The oblique setting of the table, the response of the apostles, and the bread given to the beggars, link with Tintoretto's *Last Supper* in the Scuola Grande di S. Rocco of 1577–81 which breaks with the composition of his earlier Last Suppers. Both the Tintoretto in S. Rocco and the Veronese suggest as a distant model Taddeo Zuccaro's *Last Supper* in S. Maria della Consolazione, Rome, of 1556, the source of the twin columns that separate the Last Supper from the apostles' charitable work and of the oblique setting. Veronese has set the action in the foreground and is more concerned with the picture plane than Tintoretto; both the columns and the setting of the table link with the workshop *Marriage Feast at Cana* from S. Teonisto, Treviso of 1579–80. This could be the date of the Milan *Last Supper* which would thus have been painted at the same time as, and so independently of, the Tintoretto.

Charles I of England owned two small versions of this subject by Veronese; one which was bought from Daniel Nys in Venice in 1639 and was sold to Sir Peter Lely in 1650 (it measured 38 x 28 cm.); another with small figures was sold from his collection by Gravenor in 1649/50. It is not clear which was the present canvas which was probably no. 548 in the 1686 inventory of the Alcázar, Madrid, where the dimensions fit with this canvas although the author is not specified. The other small canvas was sold from the collection of Pierre Crozat in 1751, and passed via a number of French owners to Empress Catherine II of Russia in 1772; it was one of the paintings bought from the Hermitage, Leningrad, by Paul Mellon who gave it to the National Gallery, Washington. Veronese developed the subject from Bonifazio de' Pitati's *Finding of Moses* in the Gemäldegalerie, Dresden with greater clarity in the contrast between the calm reflective Pharoah's daughter and the busy servants He appears to have produced a number of versions in a comparatively short time. I believe the prime canvas to be that in the Musée Dijon, usually classed as a school painting whose sombre dark tonality and landscape with a double vista which develops that of the *Rape* (Plate 45) suggest a date in the 1570s; it was followed by the Dresden and Lyons paintings and the Washington canvas.

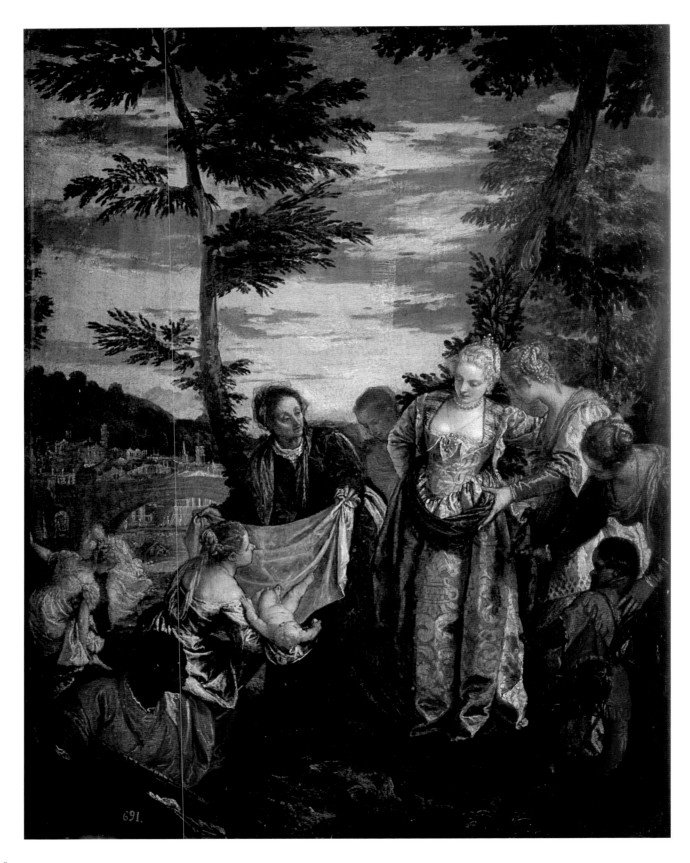

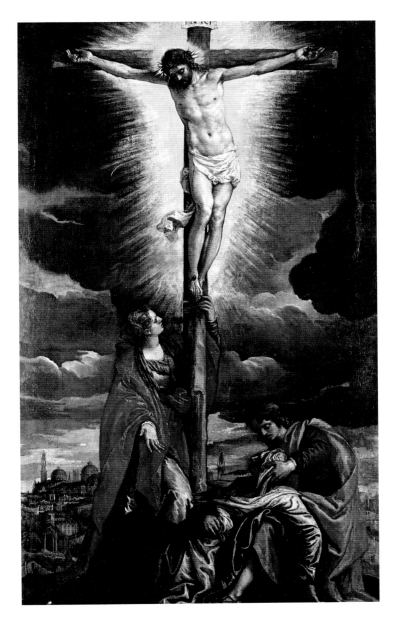

72 *Crucifixion* (above)
BUDAPEST, Museum of Fine Arts.
149 x 90 cm.

This marvellous late masterpiece, which the museum
acquired from the Esterházy collection in 1871, links
with the *Crucifixion* (Plate 63). It is the third non-
narrative version by Veronese; the earliest is probably
the undocumented side-altar in S. Sebastiano where the
colour and the treatment of the figures is close to that
of the lateral altars of 1565 the *Martyrdom of St.
Sebastian* (Plate 38) and the *Martyrdom of St. George* (Plate
39). Next was the *Crucifixion* in S. Lazzaro dei
Mendicanti from the Ospedale degli Incurabili; work
on the church recommenced in 1566, the likely date of
this variation of Titian's Ancona altar. The Virgin's
green and purple robes and St. John's red and yellow
ones set against the dark skies may give an idea of the
original colour of the much damaged 1574 *Lamentation*
in *The Church of the Annunziata* inOstuni.

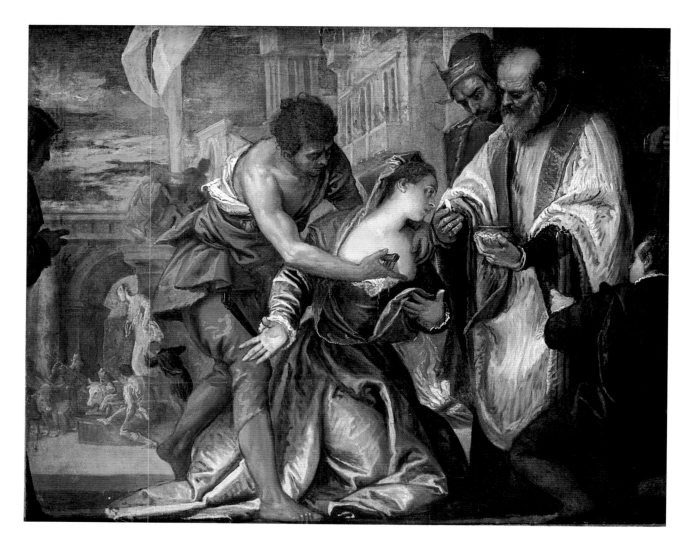

73 *Last Communion and Martyrdom of St. Lucy*
WASHINGTON, National Gallery. 137 x 173 cm.

Commissioned for the chapel of St Lucy in the
Confraternity of the Cross, Belluno this beautiful
canvas, which has suffered rubbing, was later
recorded in the Lechi collection, Bergamo in 1814,
whence it was bought for Sir William Forbes of
Fettercairn by 1827. It passed by descent until sold

Christies, London, 1971. The picture is one of those
inspired by the *Golden Legend*, but, the emphasis upon
the priest with the chalice and the host is very
different from that in the earlier version by Altichiero,
a change that may well reflect the influence of the
Tridentine re-affirmation of the worship of the host.
This belief also influenced the *Virgin and Child Appear
to St. Luke* in S. Luca, Venice, where the appearance of
the angel with the host is without precedent.

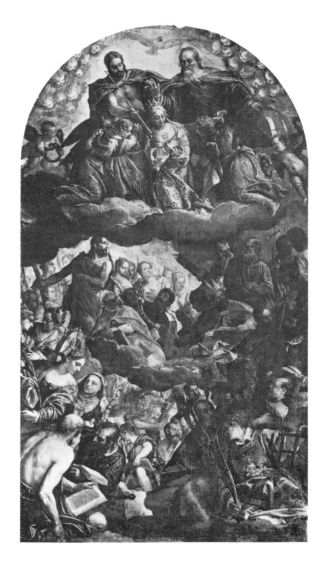

74 *Coronation of the Virgin*
VENICE, Galerie dell' Accademia, 396 x 219 cm.

This picture, which is an outstanding example of
Veronese's adaptation of Tintoretto's light effects, was
painted for the main altar of Ognissanti which,
together with the church, was consecrated on 21 July
1586. The preparatory drawings for the canvas, in
Oxford and Berlin, contain motifs that are re-used in
the Lille *modello* for the *Paradise* in the Sala del Gran
Consiglio in the Doges's Palace, Venice, which dates
from after 1584 and before 1587 (when Bardi notes

that it was to have been undertaken with Francesco
Bassano) and which confirm the date of the present
canvas as 1585–86. The inspiration for this fusion of
the *Coronation* with an *All Saints* must have come from
its location on the altar of Ognissanti (All Saints). The
attendant saints are developed from Titian's *Gloria* of
1554 which had earlier inspired the drawings of the
Allegory of Redemption now in the Metropolitan
Museum, New York, while the group of the Virgin,
Christ and God the Father are inspired by Dürer's
engraving of the *Assumption and Coronation of the Virgin*.
See: Cocke, 1984, 177

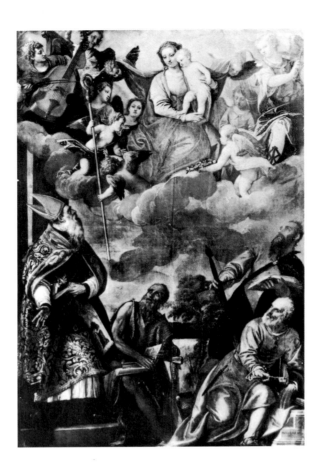

75 *Virgin and Child Appear to SS. Anthony Abbot, Paul the Hermit, Peter and Paul*
DIJON, Musée des Beaux-Arts. 341 x 219 cm.

The altarpiece was painted for the Confraternity of St. Anthony, Pesaro, to replace a polyptich by Antonio Vivarini. It was removed to France in 1799 and sent to Dijon in 1809. The execution of the picture, is usually given to the workshop; comparison of the St. Anthony on the left of this painting with the St. Frediano in Carletto's *Virgin and Child Appear to the Magdalen St. Frediano, an Unidentified Saint and a Donor* in the Uffizi reveals that the St. Frediano is flat and badly drawn and his drapery has none of the depth or life that makes St. Anthony's so exciting and convincing.

There is a problem about St. Anthony's appearance in a rich brocade and bishop's mitre looking up to the skies where the angels carry a bishop's staff; St. Anthony was famous as a hermit and although he can be shown in a sacra conversazione as in the *Holy Family Enthroned with John the Baptist, SS. Anthony Abbot and Catherine* (Plate 3) accompanied by his pig the accoutrements and action suggest some special event within the Confraternity. On the 28 May 1586 Caesar de Benedictis, about whom little is known except that he was a priest in Pesaro, became the city's new Bishop. It seems possible that he was the member of the Confraternity whose elevation inspired the imagery of this painting, for which Veronese received payment on 31st of May, 1586.

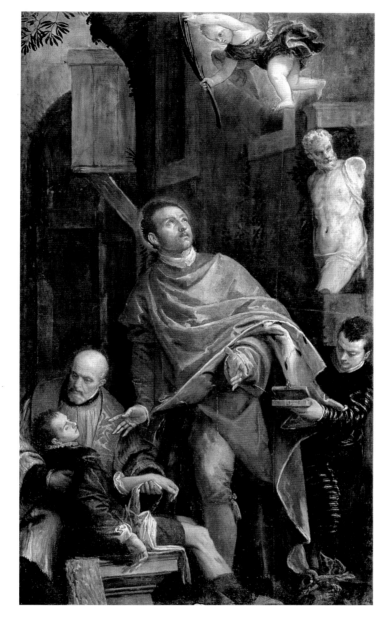

76 *St. Pantaleon Heals a Sick Boy*
VENICE, S. Pantaleone, 277 x 160 cm.

Commissioned in 1587 by Bartolommeo Borghi, the parish priest, for the high altar. It retains its original position, but this is now the right aisle, following the church's reconstruction in the late seventeenth century. The standing Virgin and Christ Child, shown in the drawing, were excluded from the finished painting because of lack of space.
See: Cocke, 1984, 127

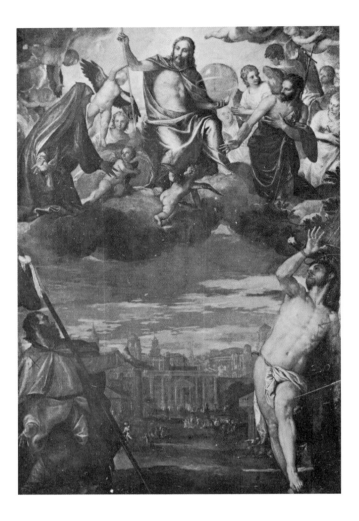

77 *The Deësis with SS. Sebastian and Roch*
ROUEN, Musée des Beaux-Arts. 350 x 220 cm.

The Church was given to the Jesuits in 1564, at which
date it was not roofed; this was completed as a
response to the plague of 1572. The main chapel was
extended by 1578 and the altar built in 1589, although
work continued until 1598. The activity in the centre
of the canvas suggests an idealized picture of the
church being built. The kneeling St. Roch is similar to
the *St. Roch* in the Museo Archeologio, Cividale, one of
two paintings commissioned in 1584. There can be no
doubt that the companion *Virgin and Child in Glory* is
from the workshop; the *St. Roch*, which is signed (as
are many clearly workshop paintings) is, to judge from
a reproduction, the painting having been stolen in
1973, possibly autograph

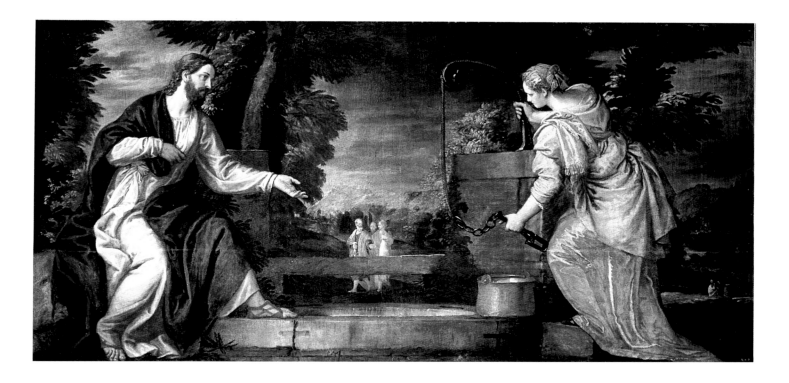

78 *Christ with the Woman of Samaria*
VIENNA, Kunsthistorisches Museum. 143 x 289 cm.

This was one of eleven Veronese's included in the 1613 inventory of the collection of Charles de Croy, the Duc d' Arschot, drawn up in Brussels the year after his death. The other autograph pictures were: the *Christ Washing the Apostles' Feet* in the Prague Castle Art Collection, the *Anointing of David*, and *The Angel Appears to Hagar and Ishmael*, both in the Gemäldegalerie Vienna. To these the workshop added: the Prague *Adoration of the Shepherds*, the Vienna *Esther before Ahasuerus*, *Susanna and the Elders*, *Christ and the Centurion*, *Christ and the Woman taken in Adultery*, *Lot and his Daughters*, and the Washington National Gallery *Rebecca at the Well*, to which should be added a *Rest on the Flight*, lost in the seventeenth century. Charles de Croy probably purchased the set on his visit to Venice in 1595. By common consent the earliest of the series was the *Anointing of David* from the 1550s. The next stage came in the 1580s, perhaps as the *Anointing of David* passed to a new patron, who planned the *Christ Washing the Apostles' Feet* (now cut down on all sides) as a companion to the *Anointing of David*, including his portrait immediately behind St Peter's right shoulder. The new taste for the display of four linked canvases prompted the commission of two further autograph paintings, the *Hagar and Ishmael* and the *Christ and the Woman from Samaria*, where large matching figures are set in similar expressive land-scapes. The remaining workshop pictures were added later, probably after Veronese's death in 1588.
See: B.L. Brown, 'The so called Duke of Buckingham series', in Gemin, 231-241; Cocke, 1984,119 and 120.

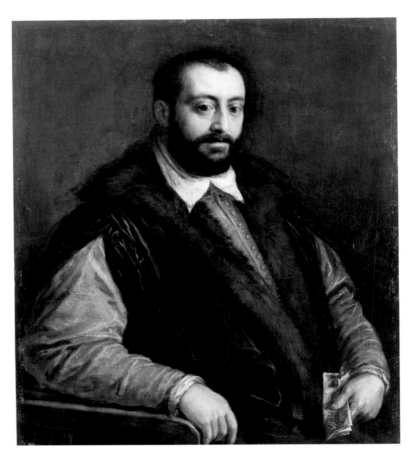

79 *Portrait of Francesco I de' Medici*
KASSEL, Staatliche Gemäldegalerie, 100 by 85,7 cm.

Inscribed 'Alt.o San F (ra) Me' (His Grace Francesco de' Medici). The attribution to Veronese, rather than Francesco Bassano, with whom it had been associated since the end of the nineteenth century, was made by Dr. Jürgen Lehmann. It rests on the resemblance with the *Portrait of Jacob König*, now in the Prague Castle Art Collection, signed by Veronese and datable to the mid 1570s. Francesco de' Medici (1541-1587) rests his right arm on the edge of his chair and holds a letter, the movement of his head, strikingly similar to that of Alessandro Contarini in Veronese's Dresden and Philadelphia portraits. The arm of the chair must have balanced a now-lost companion portrait, no doubt of his Venetian mistress, Bianca Cappella, with whom he had a notorious affair and whom he married in 1578, after the death of his wife, her husband having been assassinated in 1572. On 20 April 1586 the Medici planned a series of copies by Tintoretto, Palma and Veronese of Scipione Pulzone's portrait of Grand-Duke Francesco, in the possession of Francesco Bembo. It is uncertain whether they were made, but Veronese's Kassel portrait resembles that by Hans von Aachen of 1585-87, where Francesco wears the Golden Fleece.

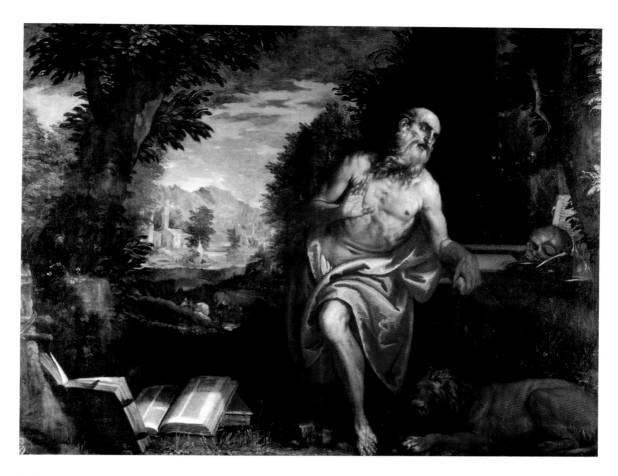

80 *St. Jerome*
CHICAGO, Art institute. 135.3 x 176.6 cm.

The picture was acquired in Florence by the Reverend John Sanford in the 1830s and was in his sale in 1839 (see Nicolson, B.M. 1955, p. 214); subsequently it was in the collection of the Earl of Stafford, thence to A. L. Nicholson in 1932 and donated to the museum in 1947. The saint is handled with the athletic assurance of the version in S. Pietro Martire, Murano of 1567, but the fussy details in the landscape where cows graze and a boat sails in front of the church are very different from Veronese's backgrounds, and connect with that in which Carletto placed his *Penitent Magdalen* (Plate 80a), formerly at Alnwick Castle, Northumberland. X-rays confirm that the saint was painted first, by Veronese, and that the landscape was then added, by Carletto. The saint's contrapposto is developed from that of the slightly earlier *S. Jerome* now in S. Andrea, Venice, which reflects Jacopo Bassano's *St. Jerome* of c. 1570 in the Accademia, Venice. The setting in the S. Andrea painting, with the flight of stairs leading to an obelisk may have a meaning that evades us, especially since the painting, which was first mentioned in S. Andrea in 1658, was probably not painted for the church. One other canvas was finished by the workshop, the *Adoration of the Shepherds* in S. Giuseppe, Venice, where the St. Jerome and the Virgin and Child on the left are autograph, but the shepherds on the right are the work of the studio.

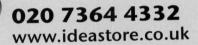